IMAGES
of America

TUSTIN

To Steve –
See – I can write more
than just SETI tech
manuals!

Thanks for all of
your support.

–Guy Ball –2011

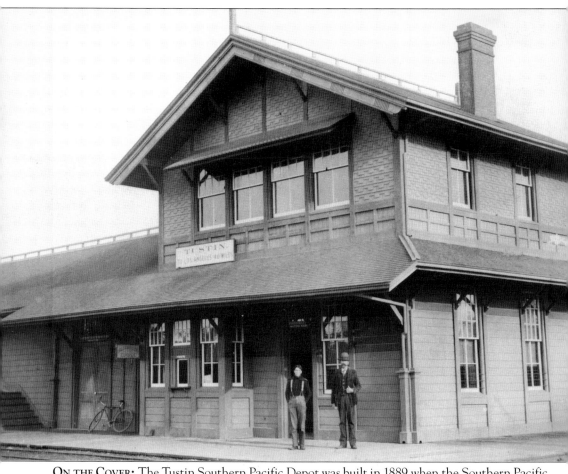

ON THE COVER: The Tustin Southern Pacific Depot was built in 1889 when the Southern Pacific Railroad was expected to continue from Anaheim, through Orange and Tustin, and then across the Irvine Ranch. James Irvine opposed the expansion, however, resulting in the line ending in Tustin. The train track originally ended with a large turntable so the locomotive could turn around to head back to Los Angeles. The train made two round-trips daily, carrying both freight and passengers. Located on the west side of Newport, between Main and D Streets, the depot housed an office, waiting room, and telegraph office. The second story was living quarters for the depot agent and family. Adjoining the depot to the north was a packinghouse for the Santa Ana-Tustin Mutual Citrus Association. Agriculture in Tustin eventually died off and the building was no longer needed, so the depot was demolished in the 1960s. The remaining Southern Pacific track running north along Newport Avenue and Esplanade Street was removed over the next decade or so. (Courtesy Tustin Area Historical Society.)

IMAGES
of America

TUSTIN

Guy Ball and
the Tustin Area Historical Society

ARCADIA
PUBLISHING

Published by Arcadia Publishing
Charleston, South Carolina

Printed in the United States of America

Library of Congress Control Number: 2009921915

For all general information, please contact Arcadia Publishing:
Telephone 843-853-2070
Fax 843-853-0044
E-mail sales@arcadiapublishing.com
For customer service and orders:
Toll-Free 1-888-313-2665

Visit us on the Internet at www.arcadiapublishing.com

To my wife, Linda, and my sons, Nicholas and Alexander. Without your loving support and patience, I could not have finished this project. It has been a long road to travel, but we have arrived!

To my mother, Diane Bashaw, who always supported me and was my Number One Fan.

To my dad, Howard Lee Ball, who taught by example that our community matters and we should give back for the gifts for which we are blessed.

CONTENTS

ACKNOWLEDGMENTS

This book truly has been a community project. I have been assisted by so many.

Foremost, this book would not have been possible without the support of the board of the Tustin Area Historical Society. Even though I am a society member and their volunteer webmaster, I was reluctant to do another book due to my work schedule. But board members Dennis Hayden and Don Ropele and Pres. Joe Sprekelmeyer encouraged me down the path to the book you are holding in your hands today.

Instrumental in the research of this book were Tustin historians Juanita Lovret, who writes the weekly "Remember When" column in the *Tustin News* and helped with historical accuracy and editorial suggestions; Bill Finken, who was my key man obtaining the photographs and background information through the Tustin Museum's amazing archives; and Carol Jordon, whose definitive book, *Tustin: An Illustrated History*, was fortunately revised and reprinted a few years ago. A special thanks goes to Barbara Hannegan, office manager at the museum, who located images and brochures, often knowing by memory where something was located.

Speaking of experts, I could always count on Cliff Prather and Rob Richardson for help on fruit packinghouses and early railroads. I asked. They knew.

Oddly enough, the "Modern Memories" chapter grew because of discussions I had with longtime residents who are part of our camping group, so a big thanks to Barry and Cindy Deibert, Dave and Linda Nitzen, George and Karen Haltman, Doug and Carol Hansen, Tony and Torie Gawel, and Matt and Patty Wood. Other great resources included Jill Leach, former editor of the *Tustin News*; Chris Jepsen with the Orange County Archives; Sharon Cebrun with Tustin Parks and Recreation; John Buchanan with the Tustin Community Redevelopment Agency; and Michele Light with the University of California, Irvine, Library Archives.

Additional photographs and information were volunteered from Victor Anderson Jr., Pete Beatty, Michael Bricker, Phil Brigandi, Steve Cate, Tony Coco, Phil Cox, Ben Crowell, Michael Demoratz, Al Enderle, Scottie Frazier, Carol, and John Garner, Bill Greene (Jr. and Sr.), Spencer Gilbreath, Stephen Gould, Margaret Greinke, Kathy Hall, Elizabeth Howard, Linda Jennings, John Kelly, Carol Kilgore, Joyce Miller, Sean Nitzen, Therese Righter, Dietrich Sellenthin, Jim Sleeper, Hans Vogel, and Jeff Williams.

One of the Internet's great features is communication with people who no longer live in your local area. I credit the friends on the Facebook page "I grew up in Tustin" and the Web site *RustinInTustin.com* with help pinning down information.

Thank you to all who helped. This is your book as well!

INTRODUCTION

Typical of many pioneering entrepreneurs during the mid-1800s, Columbus Tustin was a man looking to create something special at a time when the West was full of wide-open spaces and hope. In 1868, he and partner Nelson O. Stafford each invested $2,500 to buy a 1,359-acre parcel from the Rancho Santiago de Santa Ana land grant. Tustin and Stafford owned a carriage-making business in Petaluma, north of San Francisco, but saw opportunity in this Southern California real estate venture.

The partners split the land; Stafford received what would become a piece of Santa Ana, and Tustin took control of about 840 acres from what is now Lyon Street to Newport Avenue. The land was populated with sycamore and elderberry trees, yellow mustard plants, and wild flowers. The only inhabitants were deer, squirrel, rabbits, doves, and small game.

Tustin moved onto his land in 1870 with his wife, Mary, and their five children, Mary Jane, Martha, Ella, Samuel, and Fannie. His first house is believed to have been located south of Main Street and west of Williams Street.

Stafford did not move from Northern California until 1873. After his death in 1878, his children were active in the settlement of Santa Ana.

Slowly—perhaps too slowly—settlers began to move to Tustin's "city," mostly because of his promise of a free lot for people who built a house. Tustin had created a core town site of about 100 acres, roughly in the general area of Old Town Tustin today. Blocks were 300 square feet and lots were 150 feet by 50 feet, though some settlers bought other tracts of 5 to 20 acres. The town was centered with the intersection of D and Main Streets. (D Street changed to El Camino Real in 1968.)

Tustin soon set aside land for a school for his children and others in the community to attend. It was a one-room schoolhouse with a single teacher. Tustin established a post office in 1872 and became the first postmaster. Several stores, a gristmill, a saloon, and a blacksmith shop opened. Small houses began to appear as more settlers took a chance in this new area.

A rivalry between Tustin and William Spurgeon, the developer of Santa Ana, became intense. Each wanted his developing area to be granted an extension of the Southern Pacific Railroad out of Anaheim, which would promise business and growth. Unfortunately Spurgeon was able to offer more incentives, and Santa Ana gained the golden ring in 1878. Businesses left town, and growth in Tustin ceased for many years.

Tustin's founding father died in 1883 without ever really seeing the fruits of his labor.

Over the next 140 years, the city of Tustin grew. Other pioneering families and businessmen worked to develop the area and the rise of agriculture—particularly the desire for fresh citrus fruit "back east"—fueled the boom years. In the last half of the 20th century, a new military base, the growth of Orange County, and the expansion of residential properties helped make Tustin the dynamic and desirable suburban city that it is today.

Tustin continues to be an all-American, traditional city of neighbors, opportunity, and community. One can only hope that Columbus Tustin knows that his city—his dream—has achieved great success. Tustinites owe him a debt of thanks for taking the chance on a scrubby piece of land that, years later, they now call their hometown.

One

PIONEERING DAYS

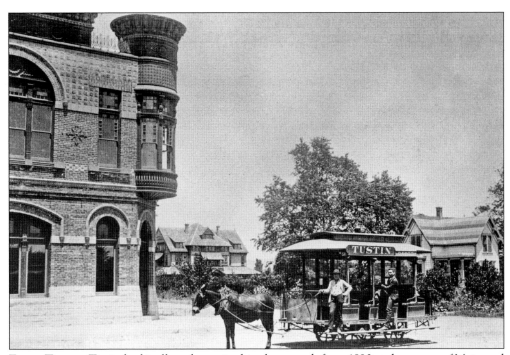

EARLY TUSTIN. Tustin had it all, as shown in this photograph from 1890 at the corner of Main and D Streets. Residents enjoyed a rock-solid Bank of Tustin (at left), a street railroad to ferry residents from town to the "big city" of Santa Ana, and even a majestic hotel (in the background) for guests and special events. The national recession of the 1890s brought hard times to Tustin, but after a few years, residents could return their focus to enjoying the growth of their rural community. (Courtesy Tustin Area Historical Society.)

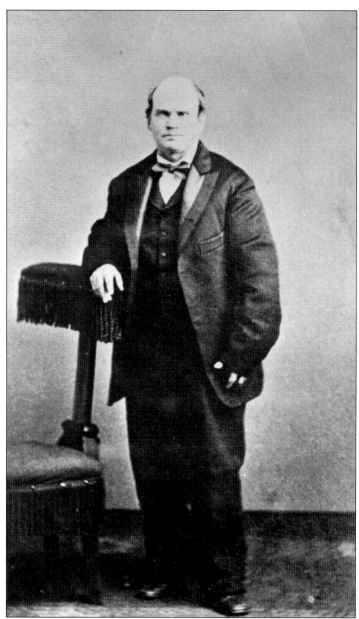

COLUMBUS TUSTIN, CITY FOUNDER. Columbus Tustin (1826–1883), his wife, Mary, and their five children moved to the area in 1870 to develop some Southern California real estate. He and partner Nelson O. Stafford purchased 1,359 acres of undeveloped land for a little under $4 per acre. Previously Tustin had tried various business ventures. He mined gold in Placerville, California; farmed in Sonoma County; and joined in the carriage-making business with Stafford in Petaluma. Tustin worked hard to encourage people to move to his new town site and offered a variety of deals to settlers, including a free lot if they built a house on it—an incentive that also worked to dissuade speculators. He personally planted hundreds of trees, which is one of the reasons Tustin is still called the "City of Trees" and has many very old trees. For a few years, Tustin was postmaster of the town site. He and his family later moved to the second floor of a commercial building he constructed on Main Street. (Courtesy Tustin Area Historical Society.)

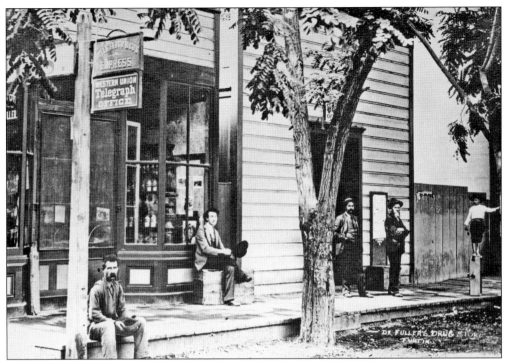

SERVICE ORIENTED. In 1890, Dr. Levi Fuller opened his drugstore, pictured above, which was located on Main Street. Besides the apothecary services, he offered a Western Union Telegraph and Wells Fargo Express office. The building was located next to the original post office. Notice the wooden sidewalks and unpaved dirt street. The buildings remained until 1914. (Courtesy First American.)

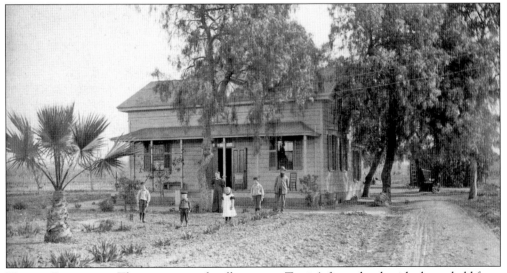

HUMBLE BEGINNING. This one-room schoolhouse was Tustin's first school, with classes held from 1872 to 1883. Anna Casad was hired to teach the students, grades one through eight, for $60 per month. The school was rented to the school district by Columbus Tustin and was located on B Street, north of Third Street. The building was eventually sold and moved to Santa Ana where it was used as a family residence. (Courtesy Tustin Area Historical Society.)

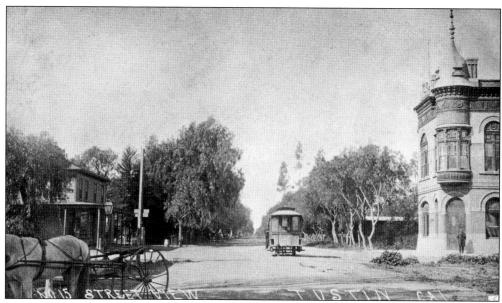

DOWNTOWN TUSTIN. This is a view of the downtown business district sometime around 1890, as viewed looking west down Main Street from D Street. The beautiful Richardsonian Romanesque–style architecture of the Tustin Bank, at right, was one of the unique landmark buildings for the city. Notice the horse-drawn buggy waiting for its owner and the streetcar making its way back to Santa Ana. (Courtesy Tustin Area Historical Society.)

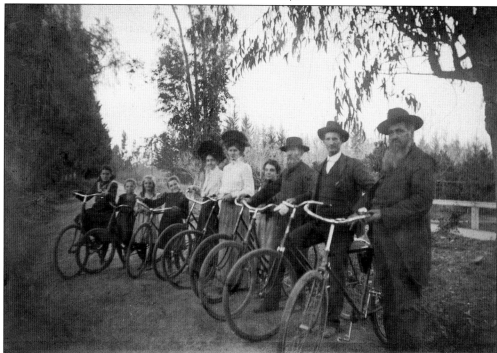

SUNDAY RIDE. The William Artz family and friends go on a bicycle outing. This photograph dates to the 1890s, when walking, bicycle travel, and horse-drawn carts or carriages were the main modes of transportation around town. (Courtesy Tustin Area Historical Society.)

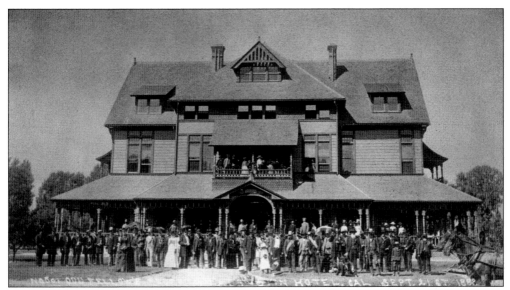

PROMISE OF A NEW FUTURE. The Tustin Hotel had a grand-opening gala in 1888 with the expectation of a tremendous boom in the city. Located at Third and D Streets, the three-story building was designed by George Preble. It contained 40 rooms, featured a broad veranda across the front, and beautiful chandeliers and a grand staircase graced the lobby. This photograph shows an Independent Order of Odd Fellows reception held that same year. Unfortunately, the city's immediate future was not so bright, and the hotel quickly fell into disrepair as recession hit the area in the 1890s. The once-beautiful building was razed in 1914. (Courtesy Tustin Area Historical Society.)

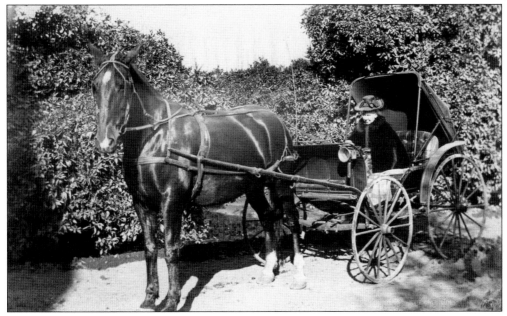

TRAVELING IN STYLE. Though shown in her later years in this photograph from 1900, Lydia Preble was quick to use her horse and buggy by herself to travel throughout Tustin and into the big city of Santa Ana. (Courtesy Tustin Area Historical Society.)

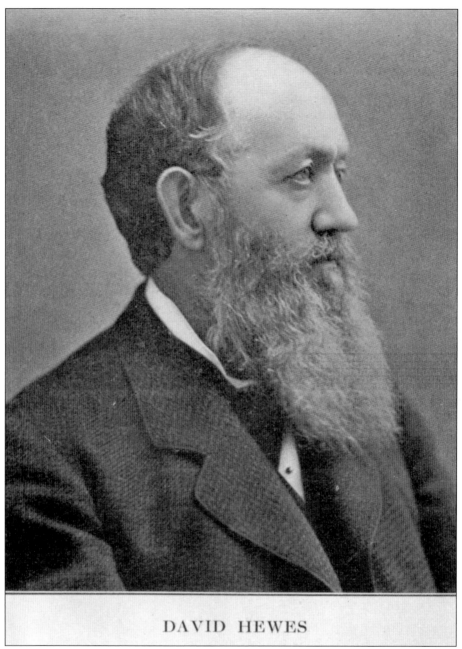

DAVID HEWES

DAVID HEWES, EARLY PIONEER. David Hewes (1822–1915) and his wife, Mathilda, came to Tustin in 1881 seeking a drier climate to help her bronchitis. Hewes made his fortune as a contractor in San Francisco and is known for contributing a golden spike to join the final rails of the Transcontinental Railroad in the 1869 ceremonies. The couple built a Greek Revival and Italianate-style home at the northwest corner of Main and B Streets. Hewes was a rancher in the Orange/El Modena area with hundreds of acres of fruit orchards. Both were great supporters of the First Presbyterian Church, donating the land and money to build the sanctuary. A few years after his wife died in the late 1880s, Hewes moved to San Francisco but eventually returned to his ranch home. (Courtesy Tustin Area Historical Society.)

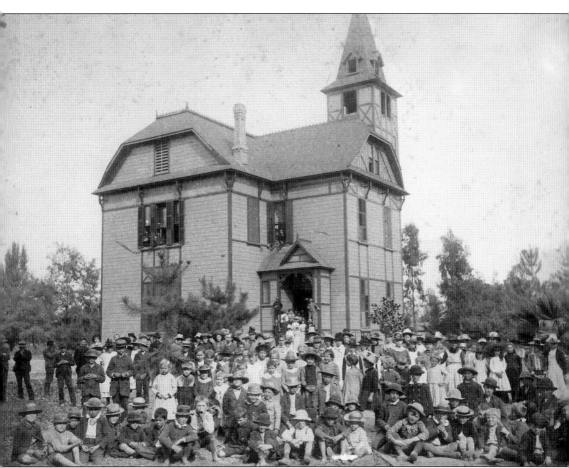

SCHOOL IS IN SESSION. In 1882, Tustin City's new schoolhouse had two rooms on each floor and a tall bell tower— all for a grand total of $5,267.50. Students from Tustin and nearby areas attended up to eighth grade. The building would later be expanded. The bell resides at the Tustin school district office at 300 C Street. (Courtesy Tustin Area Historical Society.)

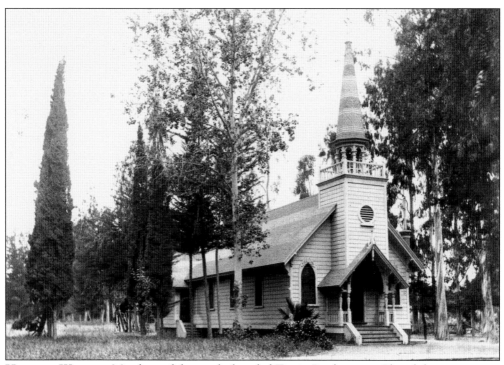

HOUSE OF WORSHIP. Members of the newly founded Tustin Presbyterian Church began meeting in 1883 in the Advent Christian Church until their Victorian-style sanctuary, shown above, was constructed at Main and C Streets. The site was that of a former saloon, and the land was donated by David and Mathilda Hewes. Although the church moved to a new and larger building in 1929, the parish kept the bell, which bears the date 1884 and is still in use today. (Courtesy Tustin Area Historical Society.)

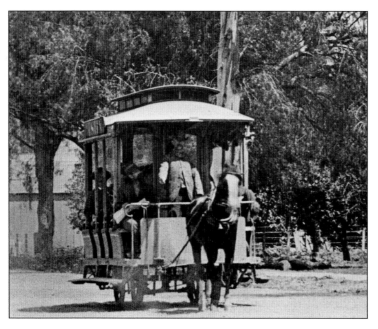

TUSTIN TROLLEY. Tustin and Santa Ana business leaders founded the Santa Ana, Orange, and Tustin Street Railway in 1886. The cars traveled on rail tracks laid in the streets. The trolley started at the Bank of Tustin on Main and D Streets, stopped in Santa Ana, and ended up in Orange. It was especially popular with those who wanted to spend a day shopping in Santa Ana. (Courtesy Tustin Area Historical Society.)

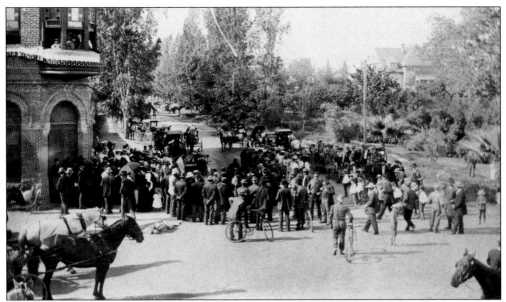

IMPORTANCE IN EDUCATION. Education in the late 1800s was as important to residents then as it is today. This photograph from about 1895 shows what appears to be most of the town attending a graduation gathering. The Bank of Tustin is seen at the left. Students stand on platforms at the right side of the street as proud parents watch from the first few rows to the left of their children. (Courtesy Tustin Area Historical Society.)

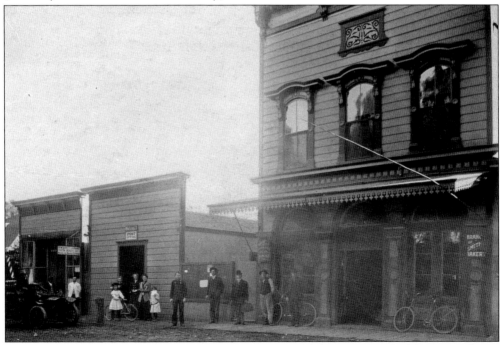

EARLY STOREFRONT. Founder Columbus Tustin constructed this two-story building around 1875 on Main Street just east of C Street. A general store occupied the first floor. The Tustins lived upstairs with their family. After Columbus died in 1883, his wife, Mary, stayed in Tustin until 1912. This photograph dates to about 1900. (Courtesy Tustin Area Historical Society.)

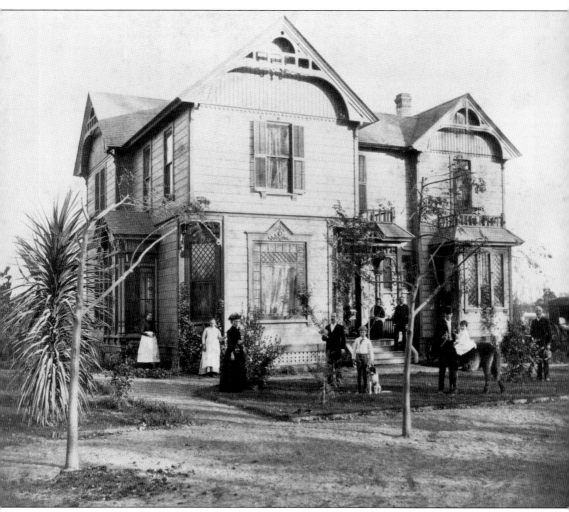

FAMILY AND FRIENDS. The Barlett family and guests spend Thanksgiving Day in 1890 enjoying the yard at their home on First Street and Tustin Avenue. At the time, William S. Barlett was active in the development of Tustin and was a prominent official with the Bank of Tustin. Franklina Gray Bartlett was a wife and mother and also played an active role in the social world of the Tustin area. She worked with several other influential women to organize the Ebell Club of Santa Ana in 1894. The women's organization devotes itself to helping the community and is still active to this day. (Courtesy Tustin Area Historical Society.)

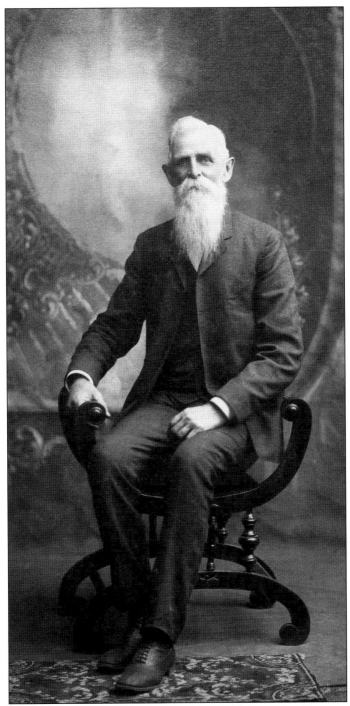

SAMUEL PREBLE, EARLY PIONEER. Samuel Washington Preble moved to Tustin in the mid-1870s along with his brother James and nephew George; at the time, Columbus Tustin was offering a free lot to anyone who would build a house on it. The Preble families all bought acreage to ranch; Samuel purchased property on Prospect Avenue. The photograph dates to about 1890. (Courtesy Tustin Area Historical Society.)

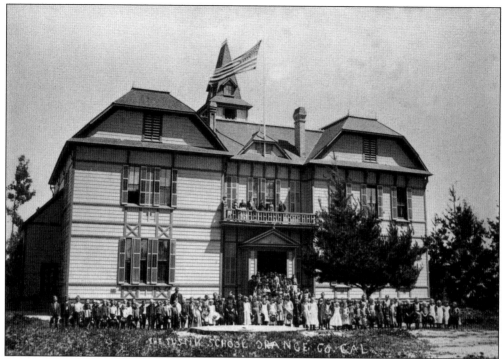

INCREASING ENROLLMENT. This photograph from around 1893 shows the student population posing with their teachers. The two-story school had been recently expanded and included eight classrooms and a library. It was used until 1914 when a new and much larger Tustin Elementary School was constructed adjacent to this site. The older school building was torn down soon after. (Courtesy Tustin Area Historical Society.)

PIONEERING SCHOOL PRINCIPAL. Before Principal John "Zeke" Zielian came to the Tustin school district in 1889, students only attended up to eighth grade and the sole schoolhouse was a small four-room building. He fought for a four-room addition and later added a ninth grade for those who wanted to further their education. In the photograph above, Zielian is shown with the ninth-grade class of 1905. (Courtesy Tustin Area Historical Society.)

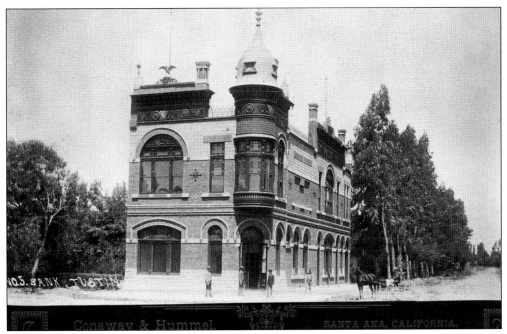

TUSTIN'S FIRST BANK. The Bank of Tustin opened for business on August 1, 1888, in a beautiful two-story Romanesque-style building at the northwest corner of Main and D Streets. The inspiring structure was designed to evoke confidence and strength for a new community. While the bank survived the Panic of 1893, it eventually closed its doors nine years later. In 1911, the First National Bank of Tustin opened at the same location and continued until it was purchased by First Western in 1959. The exterior had been modified over the years, due in part to the 1933 Long Beach earthquake. In 1963, the building was torn down. (Courtesy Tustin Area Historical Society.)

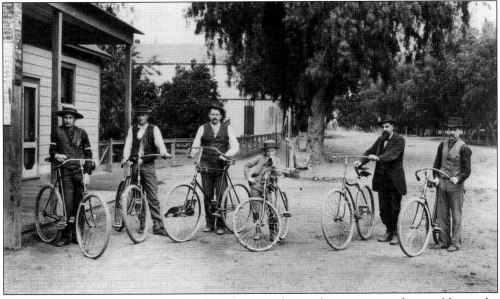

EARLY BICYCLISTS. Back in the 1890s, bicycles were the quickest way around town. Notice the hard dirt roads bicyclists had to ride on with their hard rubber bicycle tires. (Courtesy Tustin Area Historical Society.)

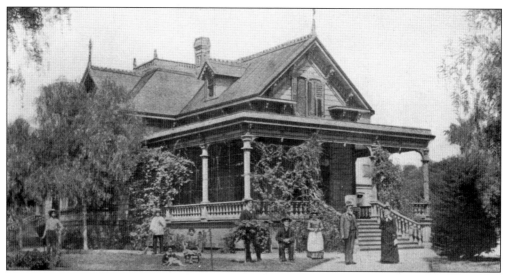

HOME SWEET HOME. David Hewes and his wife, Mathilda, arrived in Tustin in 1881. They built this beautiful Greek Revival and Italianate-style house at the corner of Main and B Streets. After Mathilda died in 1887, David continued to live in the house for several years before returning to San Francisco. The building became a slowly deteriorating boardinghouse until the 1950s when it was sold. The current owners have treated the house with loving care, restoring it to its original beauty both inside and out. It is considered one of our cherished landmark homes in Old Town Tustin. (Courtesy Tustin Area Historical Society.)

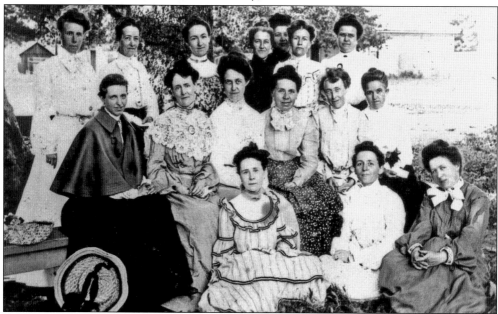

SOCIETY WOMEN. Some ladies of Tustin visited Elva Snow around 1890. Pictured from left to right are (first row) Grace Frees, Mamie Sheldon Utt, and unidentified; (second row) Rachtje Vandermuelen Bennett, Stella Preble, Jeanette Wilcox, unidentified, Nellie Wilcox Padgham, and Mattie Tustin Curry; (third row) Martha Snow Stevens, Mrs. Sheats, Elva Snow, Annie Adams Gowen, unidentified, Ella Lyons Parker, and Fannie Tustin. Many of these women were the matriarchs of the important founding families of Tustin. (Courtesy Tustin Area Historical Society.)

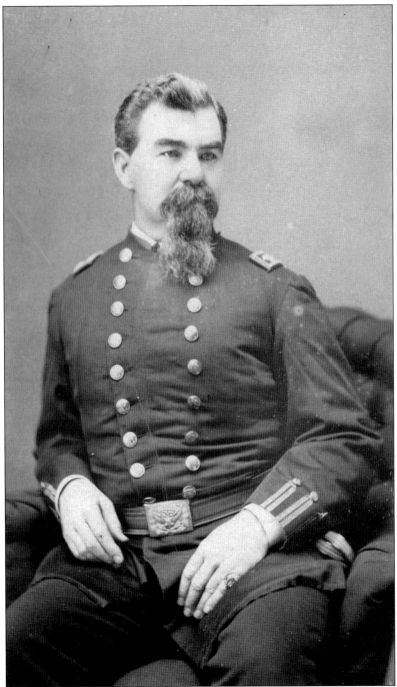

ORIGIN OF HOLT AVENUE. John Holt came to the United States from Sweden at the age of 13. He first lived in St. Louis, then Chicago, and moved to California in 1882. He bought an unimproved tract of 10 acres and later purchased 10 more at the intersection of First Street and what would become Holt Avenue. He married Louis Deathelms, from New York, and built a cozy cottage on his property. Holt experimented with planting different crops to determine which would adapt best to the soil, deciding on walnuts, apricots, and oranges. (Courtesy Michael Bricker.)

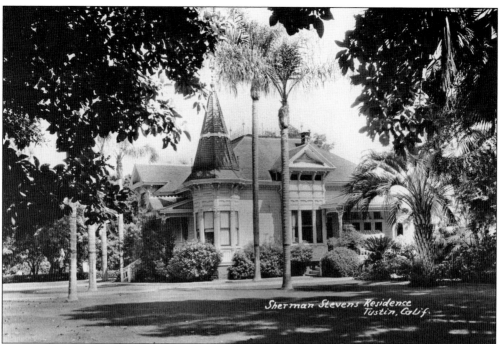

MAJESTIC HOME. In 1887, this Queen Anne–style house was built at 228 Main Street by wealthy businessman Sherman Stevens for his bride, Martha Snow. Constructed of California redwood that was shipped by boat from Eureka, the home sat among several acres of orange and avocado trees. The house was converted to a beautiful office complex in the late 1970s and is currently listed on the National Register of Historic Places. (Courtesy Tustin Area Historical Society.)

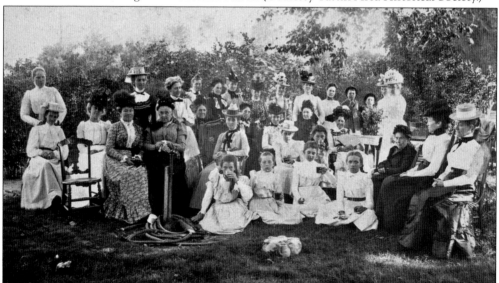

ACTIVE WOMEN. Women of the late 1800s and early 1900s were often as active as their modern counterparts in helping the community. This c. 1900 photograph shows the Ladies Missionary Society of the Tustin Presbyterian Church, one of the many service groups available to Tustin women. Other such organizations include the Pythian Sisters, the American Legion Auxiliary, and the Women's Christian Temperance Union. (Courtesy Tustin Area Historical Society.)

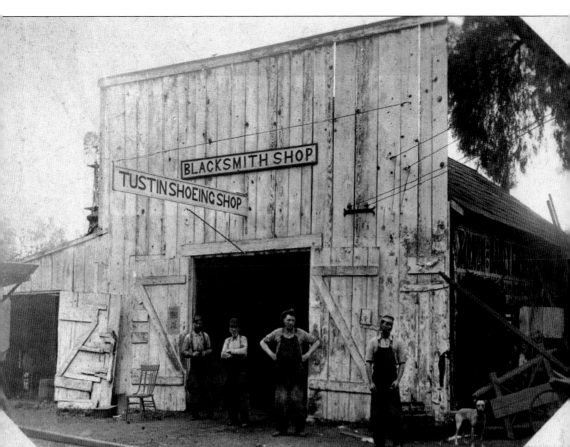

HEAVY METAL WORKERS. In the late 1800s and early 1900s, a blacksmith shop was an important business for an agricultural community like Tustin where farm equipment needed repair and horses needed shod. This shop on Main Street, between C and D Streets, was operated by John Wing and a man named Darnell. (Courtesy Tustin Area Historical Society.)

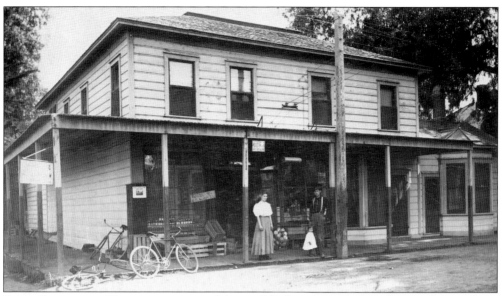

EARLY SUPERSTORE. This grocery store at Main and D Streets supplied residents with everything from food to fabric to work boots. This 1909 photograph of the store was taken when it was owned by Andrew Getty, who bought it from Lysander Utt around 1891. Originally constructed as a hotel in 1872, the building was a Tustin landmark until it was torn down in the late 1930s. (Courtesy Tustin Area Historical Society.)

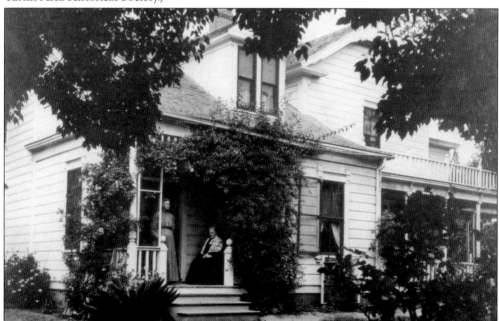

MAJESTIC HOUSE. The Wilcox Manor has an interesting history. The existing house on Pasadena Street appears to be a combination of two different structures—a single-story house and a three-story hotel, both built in the 1880s—that were relocated and combined in 1895. Over the years, the house had additional modifications. The current owners have rescued the structure, refashioning both the exterior and interior into a showplace. This photograph was taken in 1899. (Courtesy Tustin Area Historical Society.)

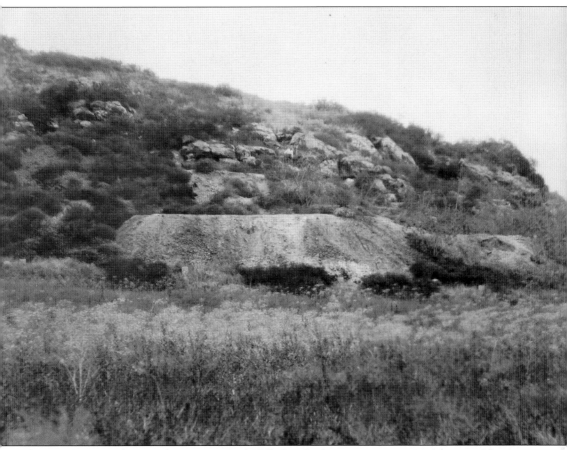

HILL OF FROGS. The area known as "Red Hill" has had many names over the years. Native Americans called the hill *katuktu*, the "hill of prominence." Spanish explorers termed the area *Cerritos de las Ranas*, "Little Hill of the Frogs." The red-colored hill was a recognizable landmark for many early travelers. In the 1880s, people first began to mine the mercury ore that gave the hill its namesake color. Various operations came and went, particularly during the two world wars when mercury was high in demand. The location near La Colina Drive and Browning Avenue is currently a state historic landmark. (Courtesy Orange County Archives.)

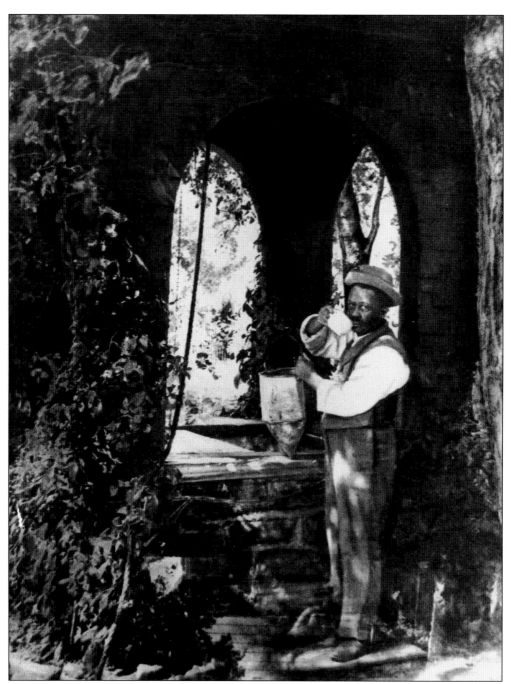

OLD OLIVER. Although the Tustin area did not have many African American residents, there was one man who lived in town and made his mark in the community. Oliver Paine and his escapades were the subjects of a variety of stories, but the town folk just accepted any frailties and appreciated his qualities. He was known as an excellent cook and reliable houseman who worked at a number of homes, including those of the James Rices, Ernest Phillips's family, and even actress Helena Modjeska. Here he is seen in 1895 at the well in front of the Modjeska house. (Courtesy Tustin Area Historical Society.)

Two

EARLY 20TH CENTURY

THE ROYAL ROAD. In the early 1900s, automobiles began to offer the freedom of travel to the American public, as mass-production of vehicles resulted in dropped prices, making cars somewhat affordable. El Camino Real was the name of the 600-mile route between the California missions running up and down the coast of California, and its travelers often dealt with unpaved roads and poor route marking. Tustin's portion of the "King's Highway" suffered the same rough conditions for many years. In 1906, the California Federation of Women's Clubs began to install distinctive mission bells on high poles resembling shepherd's crooks. On the left side of this photograph is one of the original bells in Tustin. Currently there are several newer versions of the bell along Tustin's section of El Camino Real. (Courtesy Tustin Area Historical Society.)

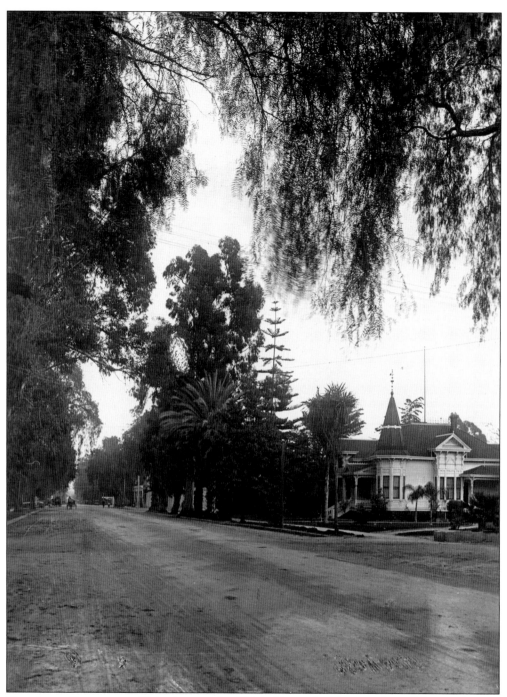

TREE-LINED BOULEVARD. This photograph of Main Street, looking east from B Street, dates to about 1910 and shows the Sherman Stevens House, the compacted dirt street, and, far in the background, both automobiles and horse-drawn carriages sharing the road. This picture may have been taken by noted Orange County photographer Edward Cochem, who captured similar scenes throughout the county. (Courtesy University of California, Irvine, Library, Special Collections and Archives.)

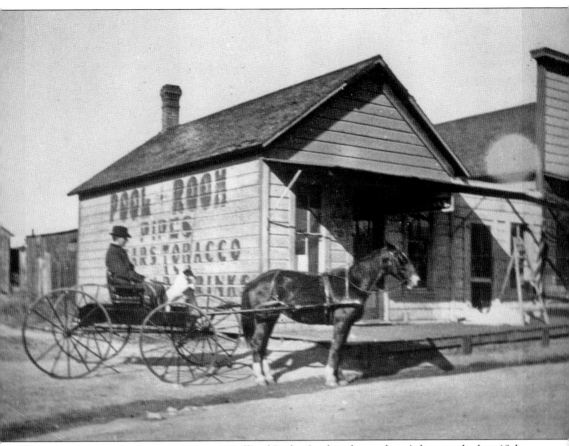

TUSTIN'S OLDEST BUSINESS? The Tustin Billiard Parlor (and its descendants) dates to the late 19th century when it was located on Main Street at Prospect Avenue. This photograph dates from 1900, when the common transportation in Tustin was walking, biking, or carriage riding. The pool hall was a common gathering spot for local businessmen, ranchers, and workers. (Courtesy Tustin Area Historical Society.)

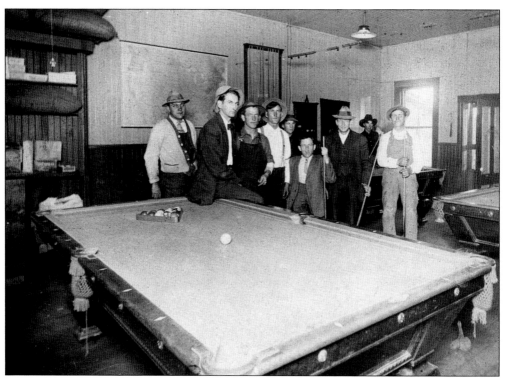

POOL HALL SURVIVES. Harry Wilcox owned the pool hall in 1911 when these photographs were taken. The business moved to its present location on D Street, now El Camino Real, in the mid-1920s with George Smith as owner. A roasted peanuts machine was added that sold a bag of them for 5¢. A lunch counter was installed in 1965. Currently known as the Swinging Door, the saloon has survived the test of time, offering locals a comfortable location to meet with friends, imbibe, and play some pool. (Courtesy Tustin Area Historical Society.)

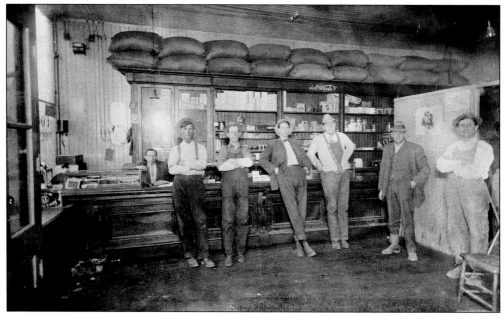

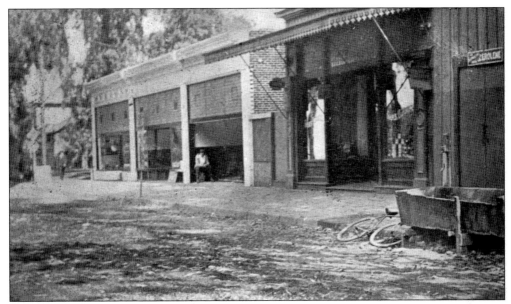

A Rustic Downtown. This photograph from about 1910 shows the south side of Main Street. While a few families owned automobiles, the more common forms of transportation were still walking, bicycling, or using horse-drawn carts and carriages. Note the water trough for customers' horses. (Courtesy Tustin Area Historical Society.)

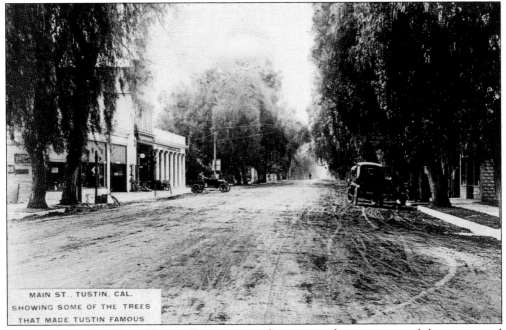

MAIN ST., TUSTIN, CAL.
SHOWING SOME OF THE TREES
THAT MADE TUSTIN FAMOUS

The Original Old Town Tustin. Dirt streets and a scarcity of cars seem out of place compared to today's Main Street. But the majestic trees and the neoclassical-style building with the columns, on the left, make this c. 1914 photograph familiar to local residents. This view is looking west from D Street. (Courtesy Tustin Area Historical Society.)

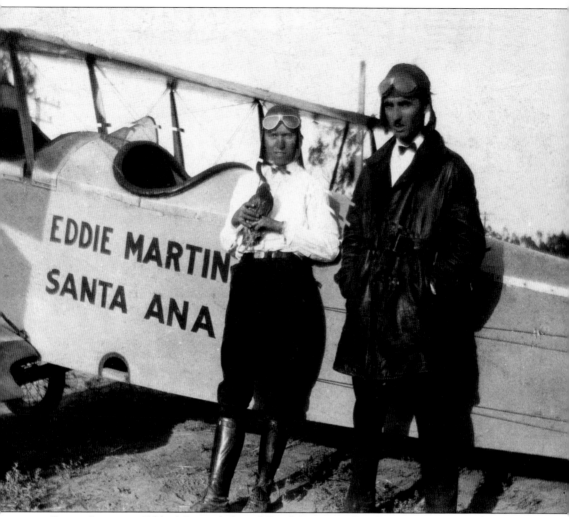

EARLY AVIATION. Eddie Martin, left, and Frank Bose stand in front of Martin's plane sometime around 1920. The pair stands on an airstrip Martin built for his flying school located on Irvine Company land near the Tustin border. Martin worked to expand the use of the airstrip by others. Thanks to his efforts, the county officially opened the Orange County Airport in 1939 for the benefit of all. (Courtesy Tustin Area Historical Society.)

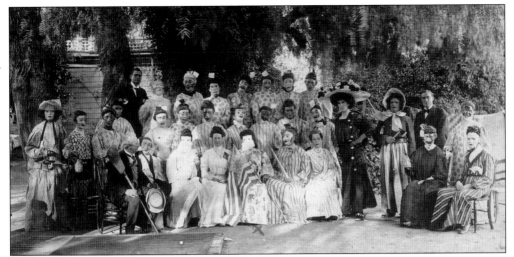

COSTUME PARTY. Costumed guests are shown in 1908 at Stella Preble Nau's dinner party for renowned stage actress Helena Modjeska. Modjeska lived briefly in Tustin after moving from her large home in what is now renamed Modjeska Canyon. She was the darling of the local social world. Her Tustin home would eventually be saved from demolition and donated to the Assistance League of Santa Ana. (Courtesy Tustin Area Historical Society.)

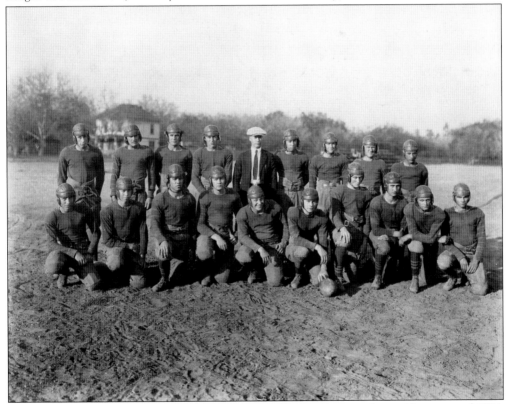

TOUGH TILLERS. Tustin High School's varsity football team is pictured in uniform around 1924. The high school opened in 1922 with the team organizing soon after. This squad took second place in their division that year, losing to Orange. (Courtesy Tustin Area Historical Society.)

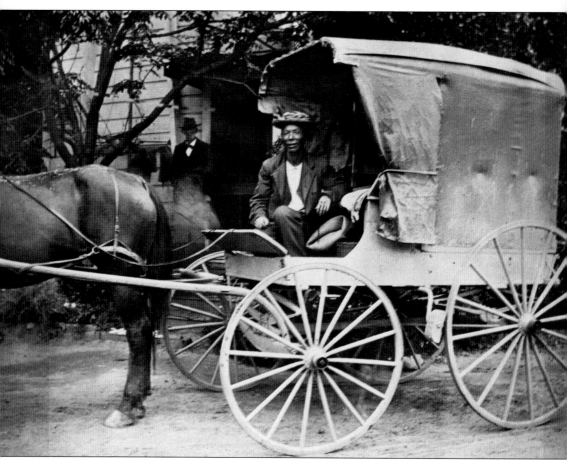

CHINESE IN EARLY TUSTIN. In the late 1800s and early 1900s, Chinese laborers were employed to lay track for the railroads, including the Southern Pacific lines. Many lived near Los Angeles and temporarily worked in the Tustin area for three or four months as ranch hands. As time went on, a small group settled in the downtown area and farmed about 20 acres of land, focusing on growing vegetables. A few of them opened laundries as well. The photograph above dates to about 1900 and shows well-known Chinese resident Chiny Lou with his horse-drawn wagon, which he used to deliver fresh vegetables throughout the Tustin area. (Courtesy Tustin Area Historical Society.)

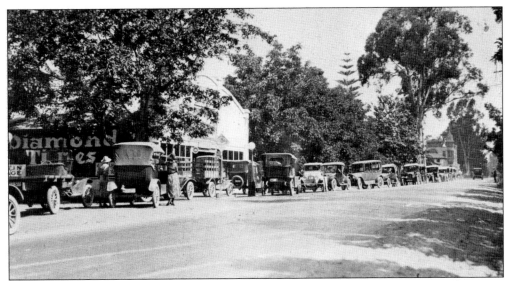

GAS SHORTAGE. Cars lined up for blocks to get their maximum 2-gallon allotment at the Tustin Garage in the 1920s. Across the country, refined gas production could not keep up with the growing number of cars on the road as ranch horses were increasingly replaced with gas-powered tractors and trucks. Oddly, the 30¢-per-gallon price of gas during those days equates to about $3 a gallon today. (Courtesy Tustin Area Historical Society.)

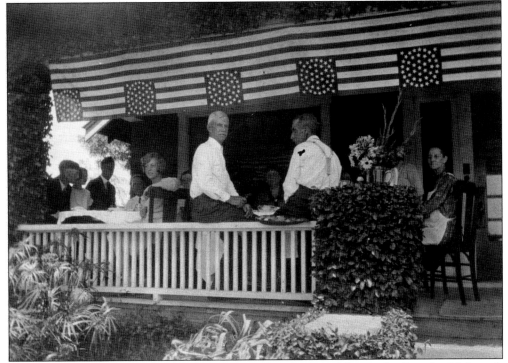

CELEBRATING INDEPENDENCE DAY. Then, like today, Tustin celebrates the Fourth of July with friends, food, and patriotic colors. Seated on the railing in 1923, J. Ernest Phelps (left) and Arthur Turner (right) and various friends and family enjoy the holiday at the Turner home. (Courtesy Tustin Area Historical Society.)

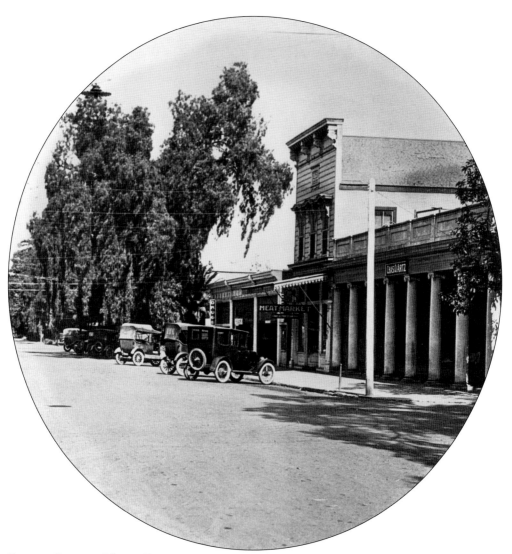

GROCERY STORE TO UNIQUE RESTAURANT. In 1915, when this photograph was taken, the neoclassical building at the right housed a new general store owned by Charles Artz. Over the years, the store has seen a variety of tenants, but for more than 32 years Rutabegorz Restaurant has served its health-conscious cuisine. (Courtesy Tustin Area Historical Society.)

HIGH IN THE TUSTIN HILLS. Charles E. Utt enjoyed one of the first and finest homes in Lemon Heights, located on the crest of the hill overlooking much of the Santa Ana Valley. The historic house, pictured here in 1925, survives today in all its original grandeur. Utt, along with Tustin businessman Sherman Stevens, purchased 600 acres of the hill in 1910 and improved it with citrus orchards, including many lemon trees, which gave the hill its name. (Courtesy Tustin Area Historical Society.)

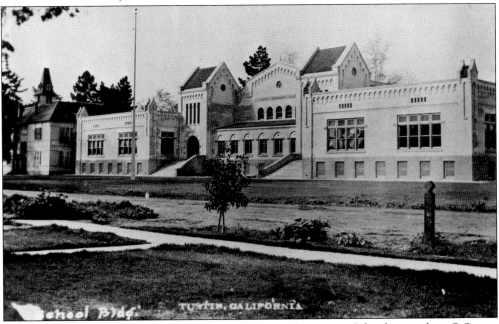

GROWING SCHOOL DISTRICT. In 1914, the new Tustin Elementary School opened on C Street, approximately where the senior center currently stands. The larger school featured eight classrooms on the first floor, a big auditorium, and a home economics classroom, wood shop, and shower rooms in the basement. The former elementary school can be seen to the left of the new school. (Courtesy Tustin Area Historical Society.)

CARRYING A PRECIOUS COMMODITY: THE CHILDREN. Tustin school bus driver Lee Byrd is pictured around 1920, looking sharp and a bit like a race car driver in front of his bus. Byrd would make the run to Laguna Beach, El Toro, and Irvine in order to bring students to Tustin schools. This was before those communities had enough students to start their own schools. (Courtesy Tustin Area Historical Society.)

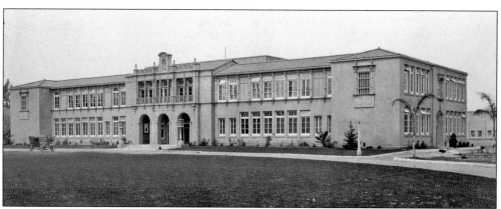

TUSTIN'S FIRST HIGH SCHOOL. In the early 1920s, state law mandated that elementary schools exist in a high school district. Rather than have the Tustin elementary schools annexed to Santa Ana, several south county districts organized into one high school district. The majestic Tustin Union High School opened in 1922 with several classrooms, a 1,000-seat auditorium, and state-of-the-art scientific classrooms. (Courtesy Tustin Area Historical Society.)

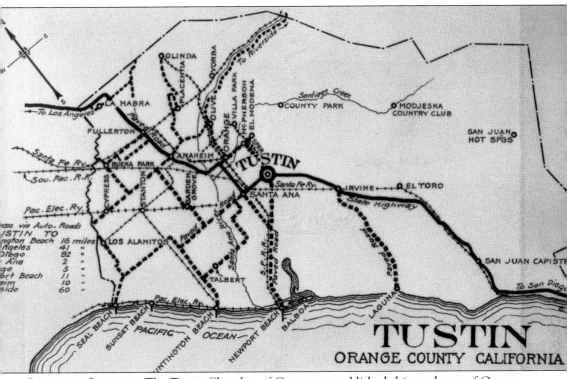

CENTRALLY LOCATED. The Tustin Chamber of Commerce published this road map of Orange County around 1914. At the time, the main travel route from Los Angeles to San Diego was State Highway 101, which ran through Tustin from Santa Ana down First Street and out D Street and Laguna Road to Irvine. The dotted lines indicated paved roads to other locations, such as the cities of Newport and Laguna. The map also shows the rail lines, including the Pacific Electric Railway (also known as "Red Cars") that ran from Los Angeles to Santa Ana and the various freight and passenger railroads. It is interesting to see the town site names like Talbert, McPherson, Olive, and El Modena that are now part of other communities. (Courtesy Tustin Chamber of Commerce.)

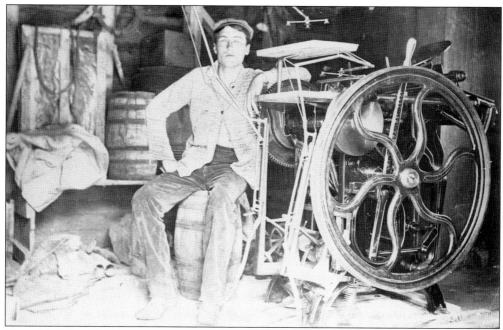

TUSTIN INVENTOR. Percy Rice (1882–1954) was the son of James and Coralinn Rice, one of the earliest families who moved to Tustin. Rice was the sort of person who would look at everyday situations and figure out an invention to make things easier. At 21, he invented a very successful automatic paper feeder for printing presses. In 1913, he invented an automatic gearshift for automobiles and a push-button tuner for radios in 1924. Not all of his inventions were widely adopted—he also invented an automatic windshield wiper for glasses. (Courtesy Tustin Area Historical Society.)

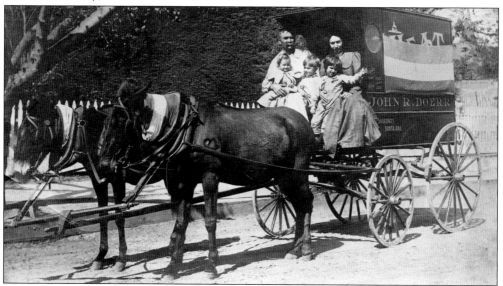

HOME DELIVERY. At the end of the 19th century, a variety of businesses would bring the store to its customers. John R. Doerr was no exception. He brought freshly cut meat directly to your home or ranch house. Here Doerr is shown with his wife and three children in 1906. (Courtesy Tustin Area Historical Society.)

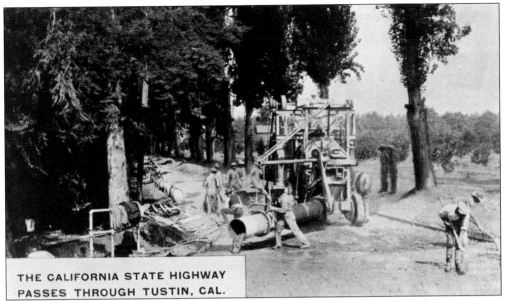

THE CALIFORNIA STATE HIGHWAY PASSES THROUGH TUSTIN, CAL.

MODERN HIGHWAY. In the beginning of the 20th century, the State of California began to create a statewide road system that included State Highway 101 and would allow vehicles to travel from San Diego to San Francisco. In Tustin, the route traveled from Irvine on Laguna Road, which became D Street at Newport Avenue, made a turn onto First Street, and continued to Santa Ana. This path held promise for the growing city of Tustin to funnel additional travelers through the downtown business district. Taken in 1914, this photograph shows construction of the highway in 1914. (Courtesy Tustin Area Historical Society.)

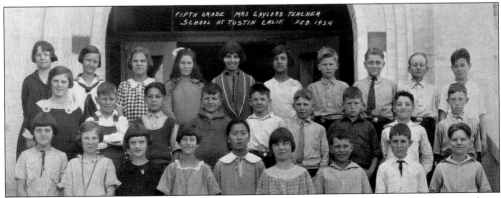

FIFTH-GRADE PHOTOGRAPH. In 1925, the fifth-grade class of Mrs. George Gaylord poses in front of the Tustin Grammar School on C Street. (Courtesy Tustin Area Historical Society.)

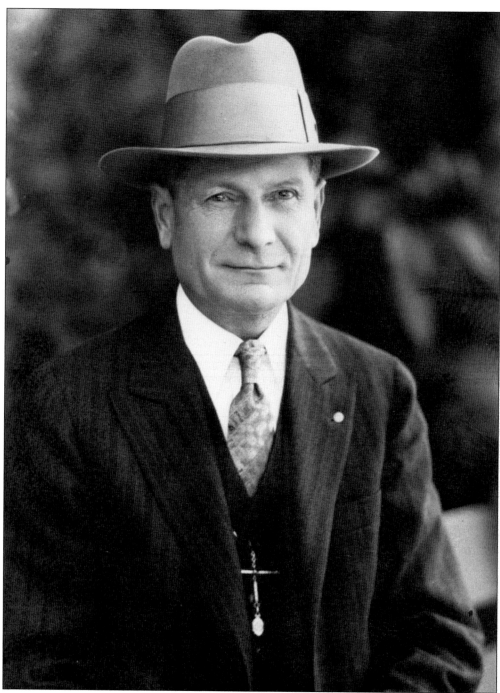

TUSTIN'S FIRST MAYOR. On September 14, 1927, the citizens of Tustin decided to incorporate as a city. This allowed citizens to better fight fire and crime, but also to defend against annexation from the City of Santa Ana, which had become a growing threat. Out of roughly 900 eligible voters, only 248 residents cast a ballot. With 138 of those votes, Tustin became a city. Byron "Barney" Crawford, shown above, garnered the most votes in the city council election and was elected the first mayor. (Courtesy Tustin Area Historical Society.)

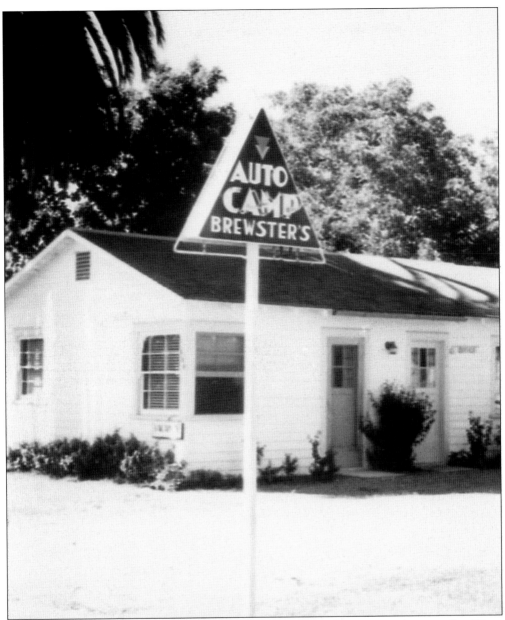

EARLY REST STOP. In the 1930s, Highway 101 was the primary driving route between San Diego and Los Angeles. Tustin was a good mid-point on the road for a spot to eat or a place to stay the night. In 1937, Basil B. F. Brewster moved his family from New York to set up one of the first auto courts (motels) in Tustin. Located near the corner of Main and D Streets, Brewster's Auto Camp offered seven cottages to weary travelers. A competing auto court was later located on Second Street. Years later, the businesses would close as the newly opened 5 Freeway carried most of the motoring traffic away from Tustin. (Courtesy Tustin Area Historical Society.)

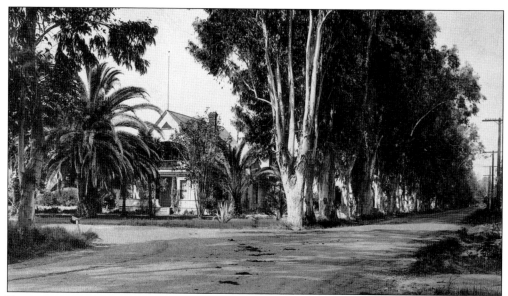

EARLY SEVENTEENTH STREET. This house was home to the family of Frank Jones, who delivered milk to many households in Tustin using his horse and carriage. It was located at the corner of Seventeenth and Prospect Streets, in what is now Von's Shopping Center. This photograph was taken in 1920 and shows the unpaved roads and lush row of eucalyptus trees bordering Seventeenth Street. In the late 1960s, the house had fallen into disrepair and was demolished. (Courtesy Tustin Area Historical Society.)

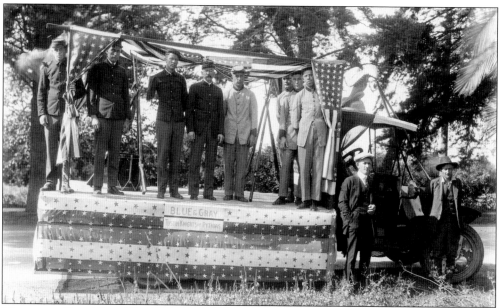

HONORING OUR VETS. The Tustin Knights of Pythias dressed in Civil War uniforms for the Orange County Armistice Day parade in 1923 in order to honor those brave men who fought and died during the war. Tustin and other towns in Orange County saw a large influx of families who left the east coast after the Civil War, seeking a better future for their families. The growth of intercontinental railroads and the promise of the new western territories helped to fuel much of the migration to Southern California. (Courtesy Tustin Area Historical Society.)

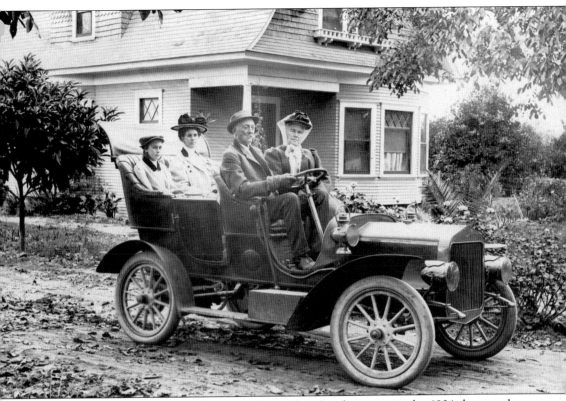

GOING FOR A RIDE. The Swartz family appears dressed for a Sunday outing in this 1904 photograph. Their home behind them is located on the future site of the Tustin High School. After the sale, the house was used as the residence of the principal and became known as the "Means House," named for a long-term principal. The building was moved to Main Street and still exists in an enlarged form. In the photograph, Peter and Ann Swartz are in the front seat. Ruby and Hattie Swartz are sitting in the rear. (Courtesy Cliff Prather.)

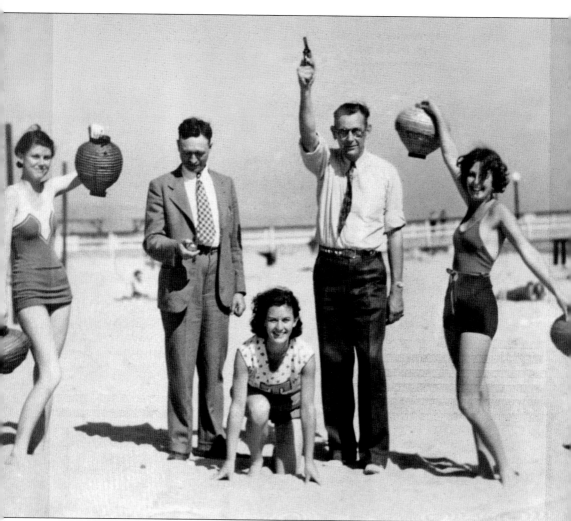

Tustin Gold Medalist. In 1932, Evelyn Furtsch became the first Orange County resident to win an Olympic gold medal. As a student at Tustin High School (THS), she played basketball, field hockey, and baseball, since there was no girls track team. She later joined the boys track team and trained with THS coach Vincent Humeston who saw her winning potential. With his encouragement, Furtsch successfully tried out for the U.S. Olympic team. At the 1932 Los Angeles Olympics, she and her teammates set an Olympic and world record in the 40-meter relay, winning the coveted gold medal. Evelyn, center, is seen here in a promotional photograph at Newport Beach the following year. (Courtesy Tustin Area Historical Society.)

MODERN DELIVERY. As the area grew, so did local businesses and the need to support them. Here in 1920, employees of the Nau-Murray Company stand by their large-capacity delivery truck complete with a load of cornflakes and other merchandise ready to be delivered to Tustin stores and markets. Years later, this company would later become Smart and Final. (Courtesy Tustin Area Historical Society.)

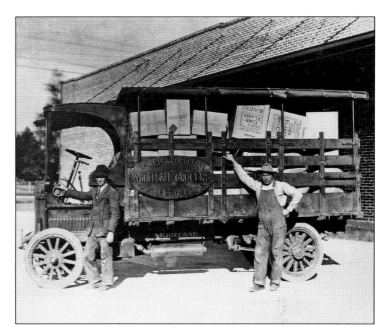

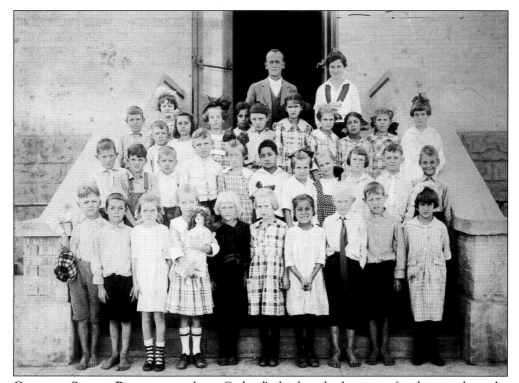

GRAMMAR SCHOOL PHOTOGRAPH. Irene Catland's third-grade class poses for photographs at the Tustin Grammar School in 1919. Principal Benjamin Franklin Beswick poses at the top of the stairs next to Catland. Beswick became superintendent of the elementary district and, years later, Benjamin Beswick Elementary School would be named in his honor. (Courtesy Tustin Area Historical Society.)

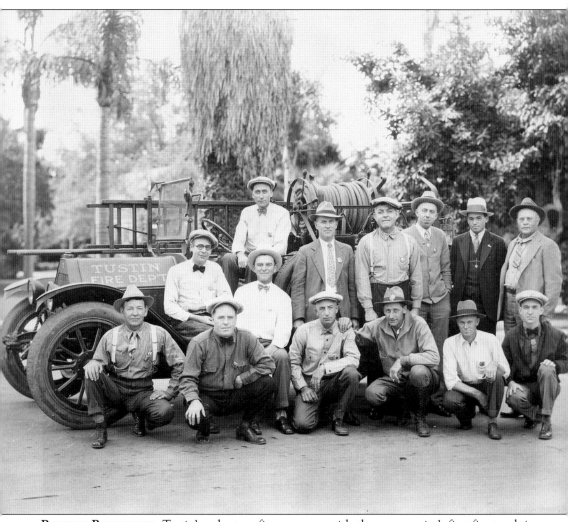

PROUDLY PROTECTING. Tustin's volunteer firemen pose with the community's first fire truck in 1929. The vehicle was modified from a 1912 Buick touring car donated by Sam Tustin, the son of the city's founder. The volunteers organized in 1924 to protect the city from fires. For many years, this meant responding when a siren on top of the First National Bank building signaled they were needed. The vehicle is now on display in the Tustin Area Museum. (Courtesy Tustin Area Historical Society.)

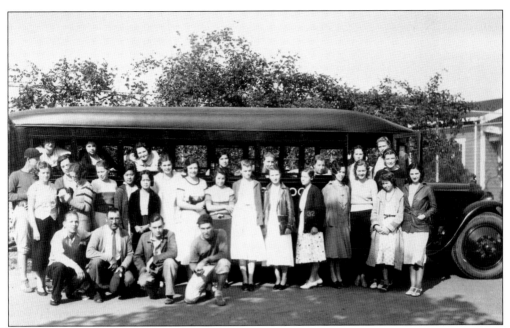

BUSES TO SCHOOL. Then, as today, the Tustin school district received students from areas outside the city. In the 1930s, this school bus brought Irvine Ranch students to the Tustin Union High School. (Courtesy Tustin Area Historical Society.)

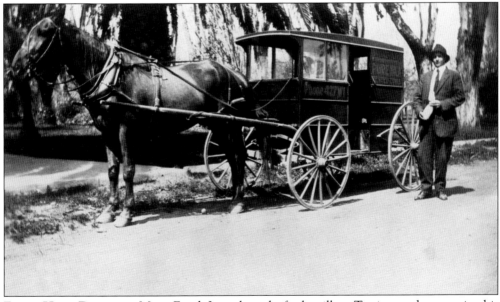

FRESH, HOME-DELIVERED MILK. Frank Jones brought fresh milk to Tustin-area homes using his horse and wagon. The milk came from a small herd of dairy cows he kept on his property at Seventeenth and Prospect Streets. This photograph, from about 1918, displays the pride Jones took in his service as he made deliveries in a suit and fedora and drove a very handsome milk wagon. (Courtesy Tustin Area Historical Society.)

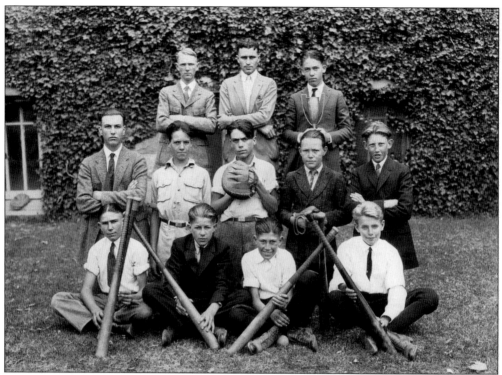

SERIOUS BASEBALL. Looking more like an Ivy League team, the Tustin Grammar School champion baseball team poses for a picture in 1922. From left to right are (first row) Al Thierry, Bill Lindsay, Ed Thierry, and Roy Weiss; (second row) coach Calvin Lauderback, Walter Huntley, Harry Miller, Lawrence Farrar, and Cecil Suddaby; (third row) Myron Dungan, Wayne Runnells, and Herb Holmes. (Courtesy Tustin Area Historical Society.)

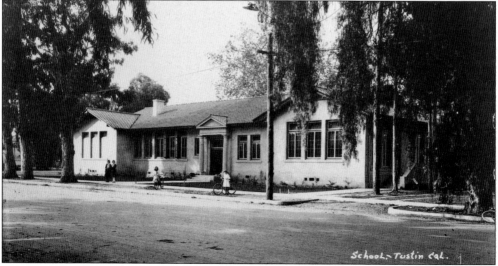

NEW PRIMARY SCHOOL. As city population and school enrollment grew, the Tustin Primary School was built on Main Street between B and C Streets, next to the Tustin Presbyterian Church. Children attended school there from kindergarten through third grade. It was opened in 1921; this photograph was taken the following year. (Courtesy Tustin Area Historical Society.)

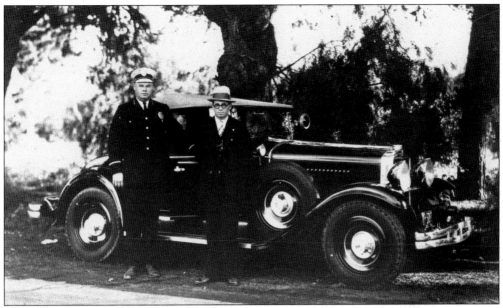

TUSTIN UNTOUCHABLES. Looking a bit like a scene from a movie about Elliott Ness, police chief John L. Stanton (left) stands next to city councilman and police commissioner Charles Logan in front of Stanton's personal car, which served as Tustin's police vehicle. Hired in 1928, Stanton became a legend as he created and molded the new police department and was its sole officer for many years. He remained chief until 1942. (Courtesy Tustin Area Historical Society.)

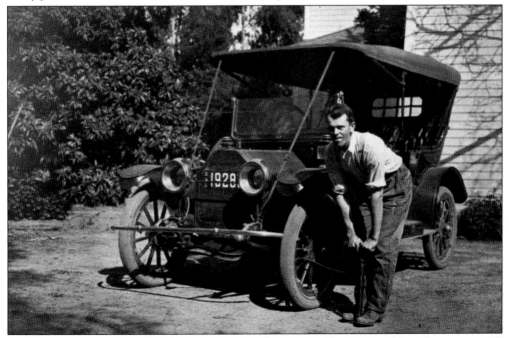

FILLING HIS OWN TIRES. Early car owners such as Perry Kenyon used hand pumps to fill their automobile tires with air. By 1915, when this photograph was taken, U.S. car sales were around 850,000. Ten years earlier, the number was closer to just 20,000. (Courtesy Tustin Area Historical Society.)

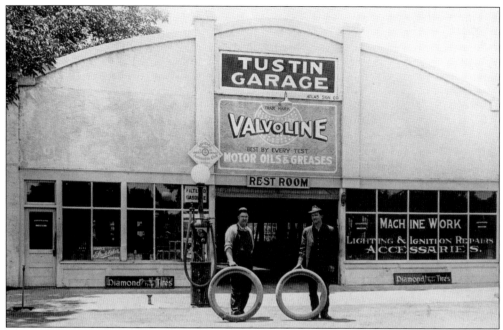

Classic Tustin Garage. Owners Nick Gulick and William Huntley display Diamond tires sold at their Tustin Garage. Originally located at Third and C Streets, they moved to the location at D and Sixth Streets to be located on the state highway. In recent years, the building was renovated and now is home of the Beach Pit BBQ. (Courtesy Tustin Area Historical Society.)

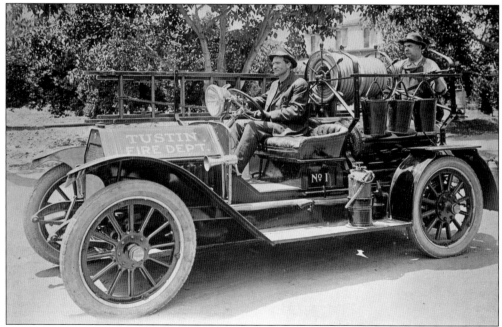

Where's the Dalmation? William Huntley, seated, and Nick Gulick show off Tustin's new fire truck soon after it came back from conversion around 1924. Previously, volunteer firefighters responded to fires by pulling a 40-gallon chemical tank mounted on two large wheels. (Courtesy Tustin Area Historical Society.)

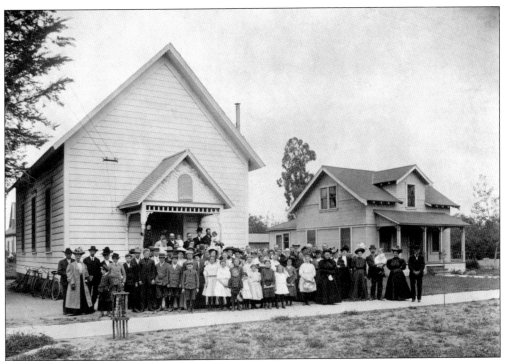

HELPING SOULS SINCE 1880. The First Advent Christian Church and parsonage and the congregation is seen in this 1912 photograph. The church organized in 1880 with 18 members, is the oldest active protestant church in the county, and has been located in the same building on West Main Street since its founding. In the mid-1930s, extensive renovations added the steeple and a two-story Sunday school facility. (Courtesy Tustin Area Historical Society.)

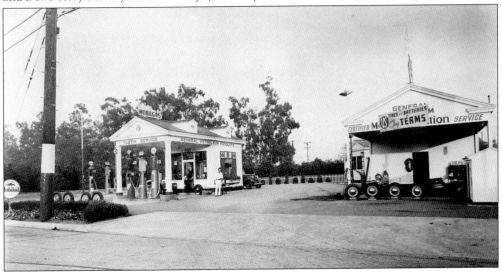

SMILING FULL SERVICE. This photograph harkens to a different time when sharp-dressed attendants not only filled customers' gas tanks, but also checked the oil and water levels, and washed all of the windows. This Tustin Service/Mobil Gas station was located at the southeast corner of D Street at First Street. Originally Bristow's Signal, the station became Tustin Service in the 1930s. (Courtesy Tustin Area Historical Society.)

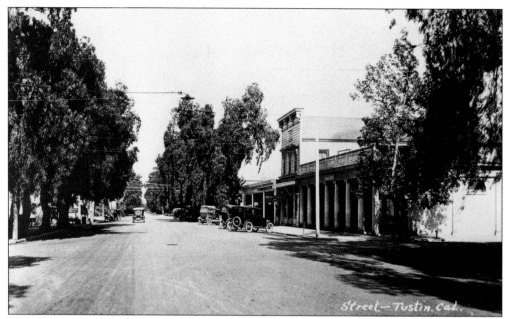

NO PARKING PROBLEM IN TUSTIN. Downtown Tustin was certainly a different place in the 1920s. Seen here with packed dirt streets and just a few cars, the view of Main Street, looking east from C Street, is that of a quiet Sunday afternoon. Note the angled parking for the businesses. While some of the buildings have changed or are no longer there, the original Artz Store can be recognized by its elegant facade of pillars that are still there today. (Courtesy Tustin Area Historical Society.)

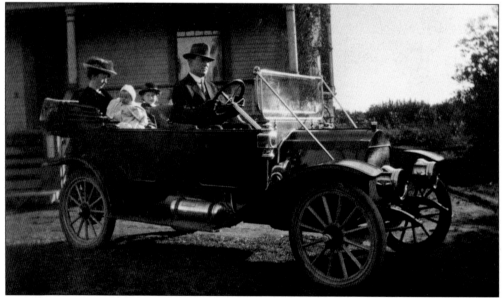

TOWN BANKER. Charlie Vance moved to Tustin in 1917 to buy shares in and manage the growing First National Bank of Tustin. Originally a native of Kansas, Vance relocated his family into a large Victorian house on Main Street a few blocks from the bank. In addition to continuing the successful growth of the bank, he also took on a variety of community roles in the growing Tustin city, including volunteer fireman. (Courtesy Tustin Area Historical Society.)

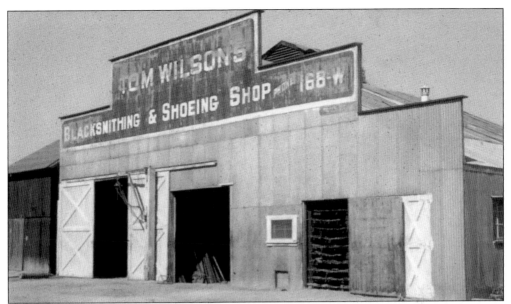

BLACKSMITHING CONTINUES. Tustin—despite no longer being an agricultural community with farm equipment to repair and horses to shoe—still has a blacksmith shop. Tom Wilson came to Tustin around 1910 and opened a blacksmith shop on C Street. Today the building that housed Wilson's shop is owned by Victor Andersen, a blacksmith for more than 60 years and one of the few remaining smithies in the Southland. (Courtesy Victor Anderson Jr.)

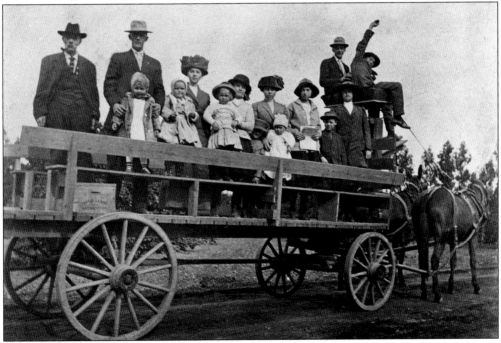

SUNDAY DRIVE. Church and religion played a large role in the early 1900s. In this photograph from 1911, the Williams, Maynard, and Sears families are pictured as they head off to the Advent Church in Tustin—riding all the way from the San Joaquin area. (Courtesy Tustin Area Historical Society.)

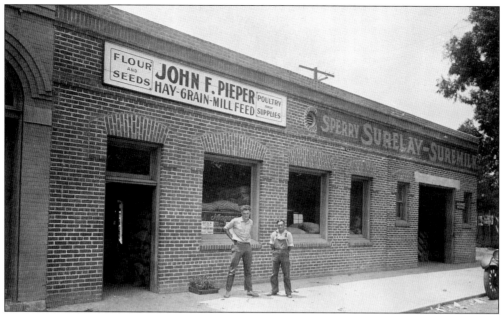

ALL A GROWER NEEDED. Pieper's Feed Store opened in 1918 serving local growers and ranchers with seed, feed, alfalfa, and whatever else they might need. The building was attached to the First National Bank on D Street, just north of Main Street. John Pieper and his family ran the store until the late 1950s. In 1966, the entire building, including the bank, was deemed unsafe due to earthquakes and was demolished. (Courtesy Tustin Area Historical Society.)

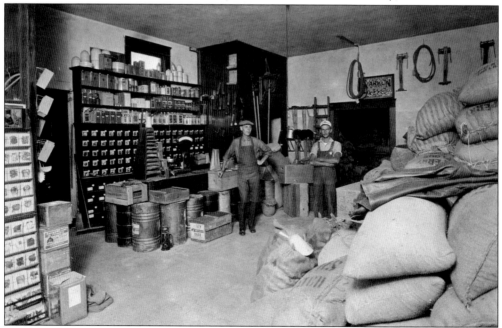

FEED, SEED, AND ALFALFA. The photograph above dates to about 1920 and shows John Pieper and Quincy Page inside Pieper's Feed Store. A customer could buy sacks of chicken feed, bales of hay and alfalfa, bins of dog biscuits, bags of vegetable seeds, and containers of fertilizers, among many other farm necessities. (Courtesy Tustin Area Historical Society.)

A BANK TO TRUST. The inside of the First National Bank at Main and D Streets was very ornate but stately, as seen in this 1916 photograph. Here E. J. "Vinnie" Cranston is at the cashier window. Longtime employee William Leinberger is seen on the right. The First National Bank did not suffer the failure of its predecessor, the Bank of Tustin. It grew successfully for more than 40 years until it was purchased by First Western Bank in 1959. (Courtesy Tustin Area Historical Society.)

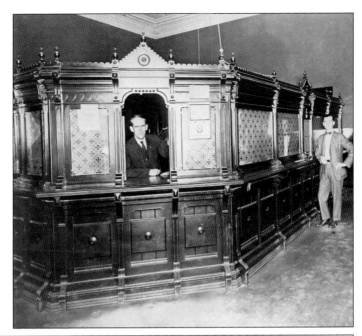

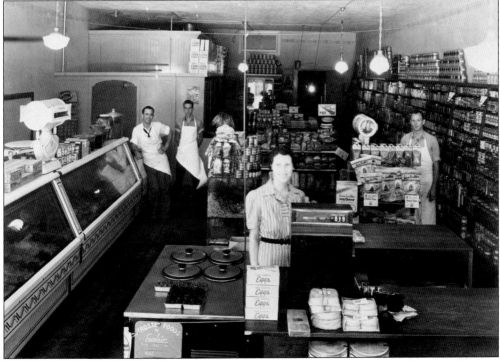

LOCAL MARKET. Carter's Grocery and Riehl's Meat Market were located at 393 D Street in a building that is still in use. They were one of several markets that offered great customer service and a good variety of basic foods and canned goods. The staff usually called customers by name and offered store credit to growers in between harvests. Employees in this 1930 photograph are, from left to right, Bob Goetting, Louis Riehl Jr., Vera Hawkins, and George Taylor. (Courtesy Tustin Area Historical Society.)

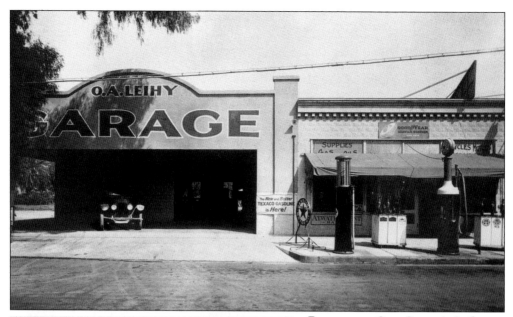

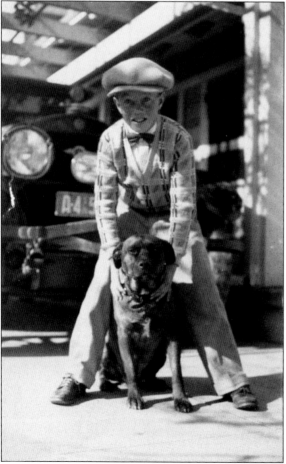

BICYCLES TO GAS. Oscar A. Leihy built his garage in 1917—located between C and D Streets on Main Street—when he saw that his bicycle business was slowing down due to the popularity of automobiles. He still worked on bicycles but found more success in catering to needs of the motoring public. (Courtesy Tustin Area Historical Society.)

DAPPER DRESSER. Oakes Newcomb holds on to a dog in a photograph reminiscent of the comic strip of Buster Brown and his dog Tige. Newcomb is seen at the home of his schoolmate John Vernon Sauers on Yorba Street sometime around 1925. The Sauers family car, an Illinois-made Velie touring car, is behind him. (Courtesy Tustin Area Historical Society.)

WORLD WAR I VET. Louis Riehl Sr. poses in this 1918 photograph in his World War I cavalry uniform with his horse. Riehl returned to Tustin after the war and eventually opened a successful meat market on D Street. (Courtesy Tustin Area Historical Society.)

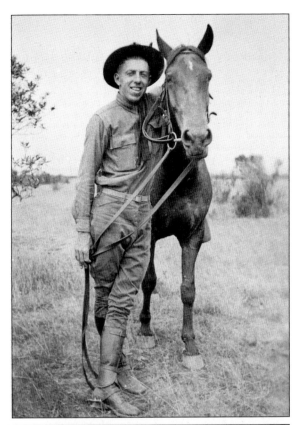

BETTER BUTCHERS. Preston's Meat Market was located inside Cox's Market, as seen in this photograph from around 1930. Charley Preston (below, left) and Wilbur Jackson were well-known for better-quality meats and sausages. With freezing food not as widespread as today, a local source for fresh meat was important. (Courtesy Tustin Area Historical Society.)

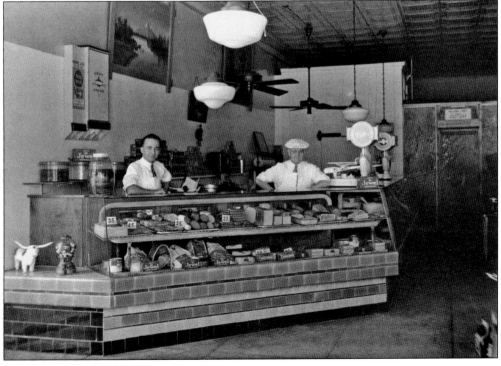

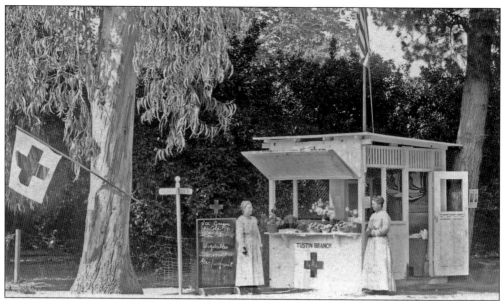

HELPING SUPPORT OUR SOLDIERS. Tustin women raised money for the Red Cross during World War I at this roadside stand at D and Sixth Streets. In addition to grapefruit, lemons, and vegetables, they also sold ice cream and candy. Because the stand was located on the relatively busy Highway 101, the women often did well with passing travelers. (Courtesy Tustin Area Historical Society.)

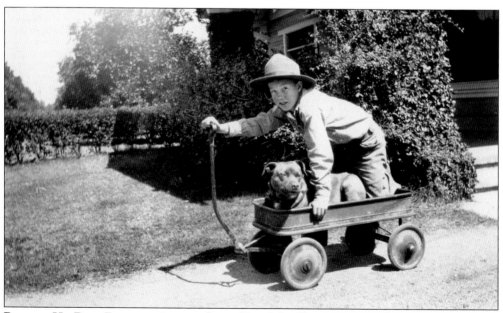

BOY AND HIS DOG. Fun comes in many forms. Here John Vernon Sauers takes a ride with his dog and wagon in 1925. Sauers went on to serve in the Army Air Corps and was a beloved teacher at Tustin High School for many years. (Courtesy Sauers family.)

Three

AGRICULTURE

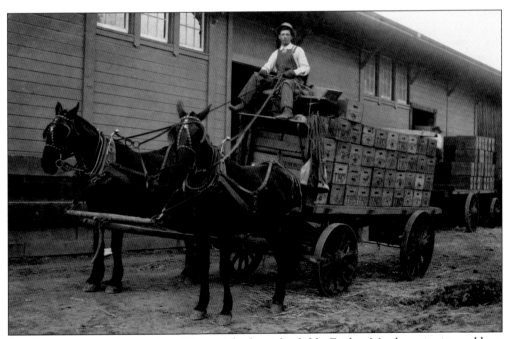

STRAIGHT FROM THE FIELDS. Coming straight from the fields, Fenlon Matthews is pictured here around 1910 riding atop a horse and wagon with a full load of fruit from the pickers. The fruit would then go to the packinghouse to be sorted and shipped by refrigerated rail cars to various destinations east. For the next 50 years, the citrus industry was the catalyst of Tustin's growth. (Courtesy Tustin Area Historical Society.)

TRAYS OF FRUIT. Before citrus orchards became king in Tustin, walnuts and apricots were the major crops for growers. Pictured here around 1922, John W. Sauers is next to his crop of apricots that were split in half and are drying in trays. Sauers stands next to his Velie touring car. (Courtesy Tustin Area Historical Society.)

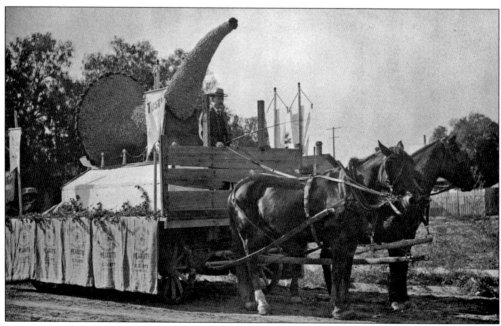

PEANUTS IN TUSTIN. Charles Edward "C. E." Utt is the "Peanut King" on this 1905 float promoting Utt's peanut crop at the county-wide Parade of Products in Santa Ana. While Utt is more known for his lines of fresh juices and jellies, he dabbled in a large variety of crops during his lifetime, including peanuts, chili peppers, grapes, and citrus. (Courtesy Tustin Area Historical Society.)

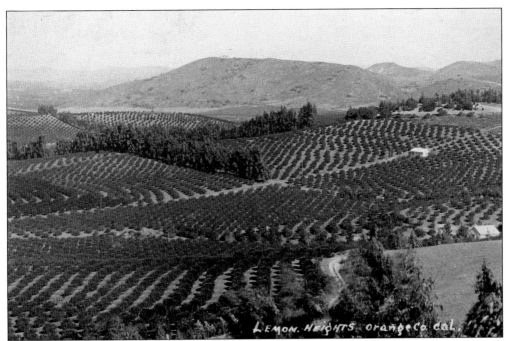

ORCHARDS AS FAR AS THE EYE CAN SEE. This photograph from 1925 is taken from the hills of Lemon Heights, just north of the main city of Tustin. Thousands of acres of fruit trees produced many million pounds of fruit over the next 30 or so years before the orchards slowly closed down and the construction of private homes took their place. (Courtesy Tustin Area Historical Society.)

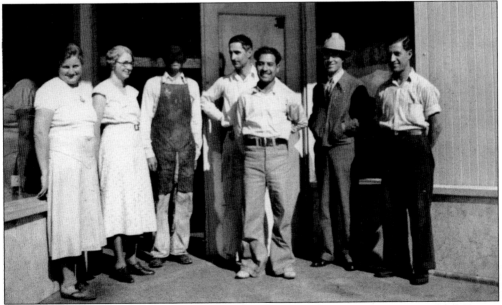

TUSTIN JUICE CREW. This 1935 photograph shows the Utt Juice Company's regular full-time production crew that handled Utt's large line of fruit products. From left to right are Mary Schellhous, Vera Pafford, Hubert Melton, Frank Bose, Eugenio Jimenez (in front), Arcy Schellhous, and Boniface "Boney" Jimenez. Additional temporary help was hired as needed during bottling season. (Courtesy Tustin Area Historical Society.)

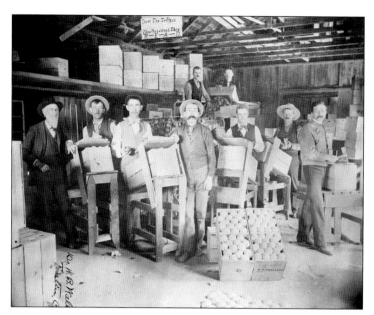

EARLY ORANGE GROWER. In 1892, Dr. W. B. Wall's packinghouse operation included a man-operated treadmill to provide power for sizing the oranges. Wall, left, was the first president of the Orange County Medical Association and was an early orange grower in Tustin. His orchard was between Tustin Avenue and Yorba Street, about where the 55 Freeway is today. (Courtesy Tustin Area Historical Society.)

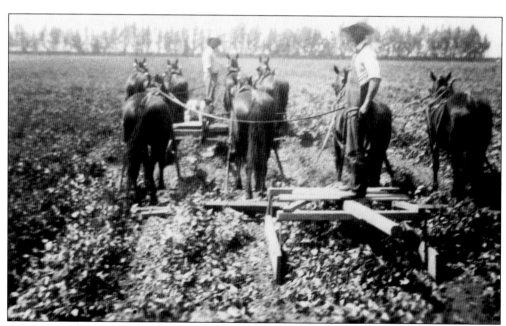

CROPS BEFORE HOMES. Before the Tustin Meadows residential development began in the late 1960s, the land was all farmland. This photograph dates to about 1936 and shows farmers cutting lima beans for harvest. Many of the farmers were Japanese who leased the land from the Irvine Company and lived near Browning and Bryan. The families were forced to relocate during World War II and generally didn't return when the war was over. (Courtesy Tustin Area Historical Society.)

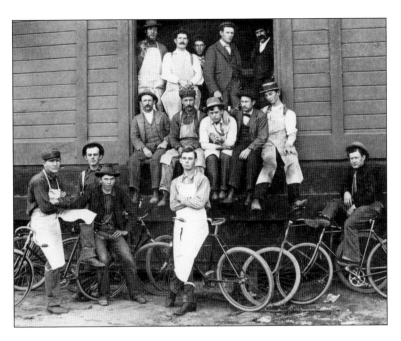

TAKING A BREAK. Crew members at the Tustin-Orange Packing House pose for a picture around 1900. At the time, the numerous packinghouses in the city provided seasonal work for hundreds of residents who graded, sorted, and cleaned fruit for markets across the United States. (Courtesy Tustin Area Historical Society.)

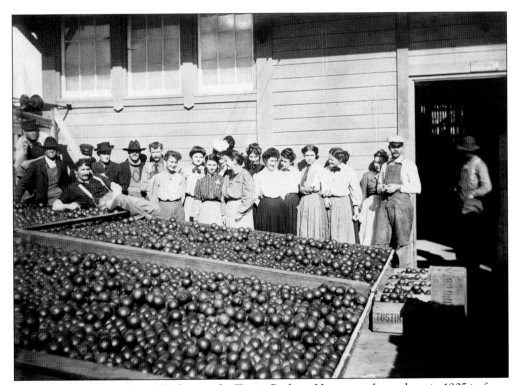

READYING FRUIT FOR SALE. Workers at the Tustin Packing House are shown here in 1905 in front of the racks where the fruit had been hand sorted, cleaned with water, and slowly air-dried before packed into cases for shipment. (Courtesy Tustin Area Historical Society.)

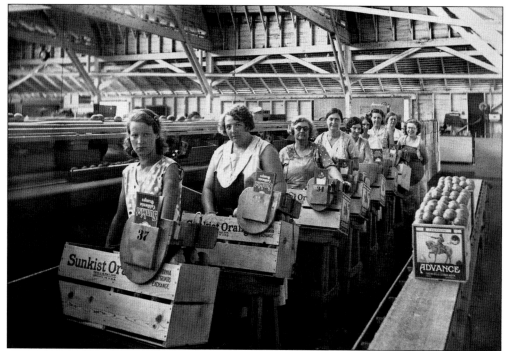

WORKING HARD. These ladies are selecting and grading fruits that come down a conveyor belt to be boxed and shipped to Sunkist orange purchasers all across the country. This particular packinghouse was the Tustin Hills Citrus Association located on Newport Avenue. During harvest season, the packinghouses would run at full speed in order to get the fresh produce to market as soon after picking as possible. (Courtesy Tustin Area Historical Society.)

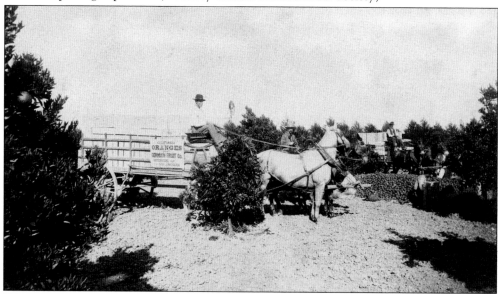

WORKING THE FIELDS. Horses and wagons, such as the one in this *c.* 1910 photograph of Hiram K. Snow's orchard, were used to haul oranges from the field to the packinghouse. Snow was one of the original settlers who took advantage of Columbus Tustin's offer of a free lot to those who built a house on it. (Courtesy Tustin Area Historical Society.)

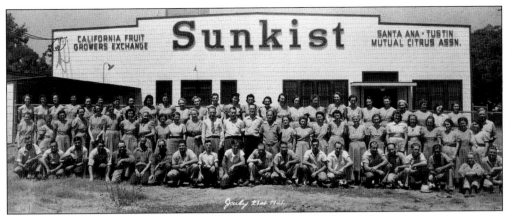

SUN-KISSED FRUIT. The employees of the Santa Ana-Tustin Mutual Citrus Association pose in front of their packinghouse on Newport Avenue, north of First Street, on July 21, 1941. During the picking and packing season, the number of employees temporarily swelled with housewives and high school kids helping get the product packed and to market. (Courtesy Tustin Area Historical Society.)

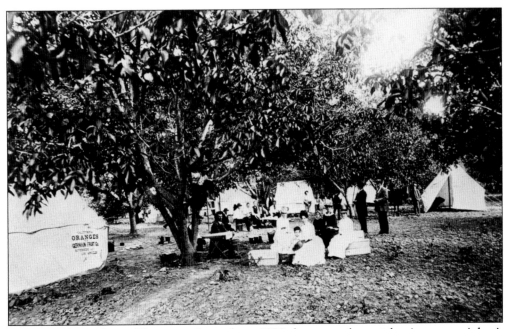

ANOTHER CASH CROP. This scene from about 1890 shows a walnut pickers' camp at Adam's Grove, probably the orchard of P. T. Adams that was south of Main Street and west of Williams Street. Walnuts were another early crop that did well for Tustin growers. (Courtesy Tustin Area Historical Society.)

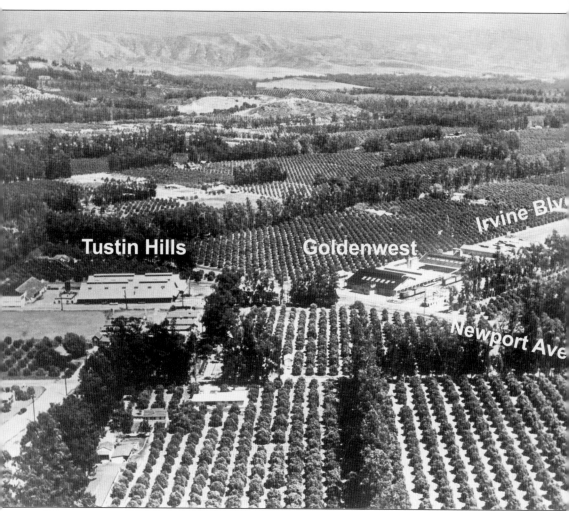

PACKINGHOUSES. This photograph from about 1950 shows two of the major fruit packinghouses in the north Tustin area. The Tustin Hills Packing House sat next to a Southern Pacific Railroad line that ran parallel to Holt Avenue. The Goldenwest Packing House was located diagonal to Tustin Hills and ran alongside Irvine Boulevard, which then ended at Newport Avenue. In the 1950s, a widespread disease called "quick decline" was spread by aphids and wiped out tens of thousands of trees in Orange County. Many growers decided the dropping price of fruit and the cost to replant new trees was too much and they started to look towards selling their land. Most of Tustin's packinghouses were out of business and demolished by the 1960s. (Courtesy Tustin Area Historical Society.)

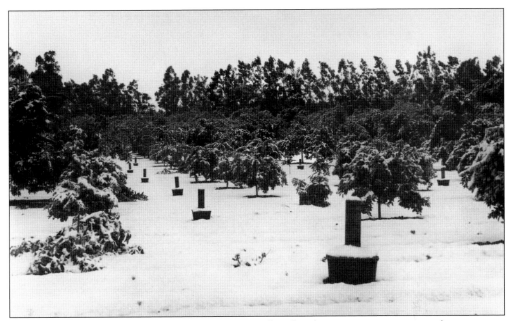

SNOW IN THE ORCHARDS. Snow in 1949 required orchard operations to use smudge pots as a method to save orange trees and protect fruit from cold damage. Anytime temperatures dropped below 28 degrees, growers would light up the smudge pots which were filled with coke or oil. This provided some increased level of heat to help reduce damage from the winter cold. (Courtesy Tustin Area Historical Society.)

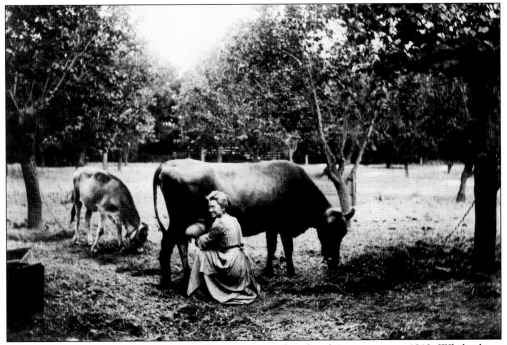

FRESH MILK. Hattie Gulick is seen milking a cow on her family's property in 1912. While there were a few local milkmen who would deliver fresh milk, families often had some livestock that provided their own fresh milk and eggs. (Courtesy Tustin Area Historical Society.)

MARCY RANCH. Around 1910, Chicago businessman George Marcy established a 1,350-acre ranch in the hills of north Tustin. He grew oranges, lemons, and grapefruit. Over time he amassed about 17,000 acres and became one of the area's largest citrus producers. After

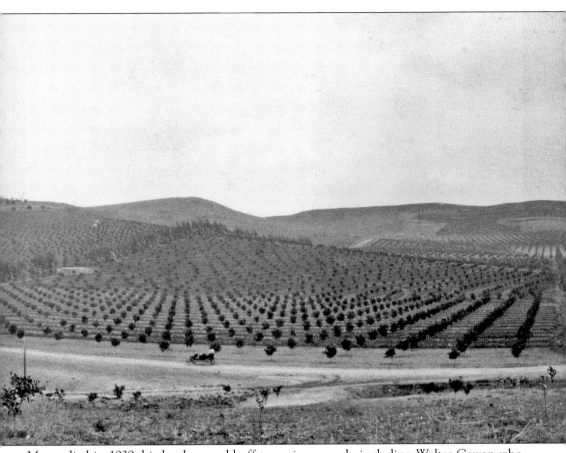

Marcy died in 1939, his land was sold off to various people including Walter Cowan who saw potential in creating residential properties. (Courtesy Tustin Area Historical Society.)

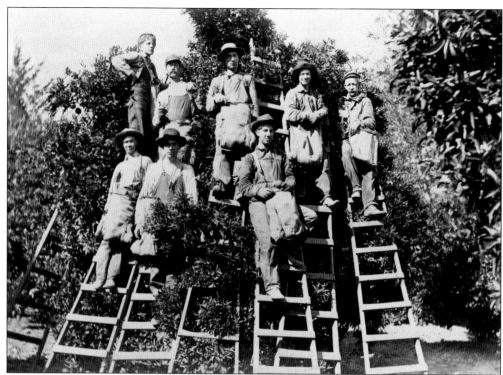

HARDWORKING HARVESTERS. Picking citrus required teams of men climbing up trees to quickly gather the ripening fruit, as seen in this photograph from about 1912. Large orchards competed with each other when trying to hire enough pickers for a common harvest time. Often there were not enough locals to do the job and immigrants from Mexico came to work. (Courtesy Tustin Area Historical Society.)

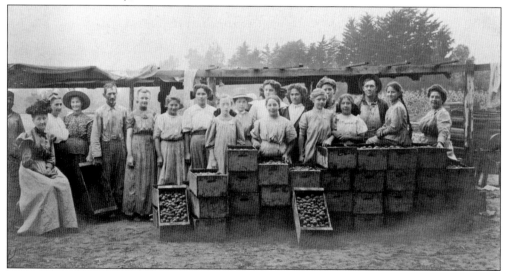

HARVEST TIME. Housewives and young people were hired to help the apricot harvest crew. Men shook the trees and picked up the fruit which the women would cut in half, removing the pits. The fruit was spread out and dried on trays. The workers, especially the teenagers, thought it a wonderful place to flirt and court. (Courtesy Tustin Area Historical Society.)

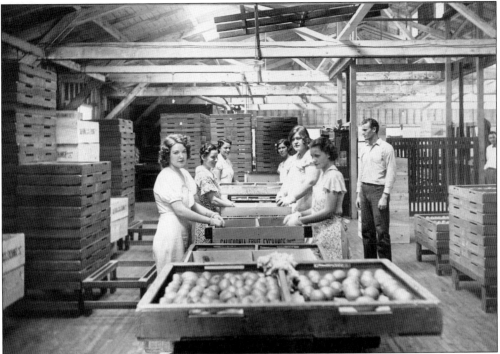

ORANGES FROM TUSTIN. The Golden West Citrus Association's packinghouse was located at the corner of Newport Avenue and Irvine Boulevard, approximately where the Packers Square center is located. The packinghouse was one of four in the city that were owned by different associations of growers in the area. This photograph dates to about 1933 and shows workers packing fruit crates for shipment to market. (Courtesy Tustin Area Historical Society.)

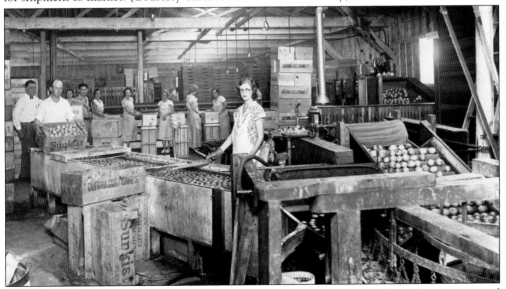

CHECKING FRUIT. This photograph was taken in 1933 at the Golden West Citrus Association and shows a woman culling frost-damaged lemons as they float to the surface of the water. At right, lemons undergo treatment in a weak copper sulphate solution to kill possible fungus that could damage the fruit during transit. (Courtesy Tustin Area Historical Society.)

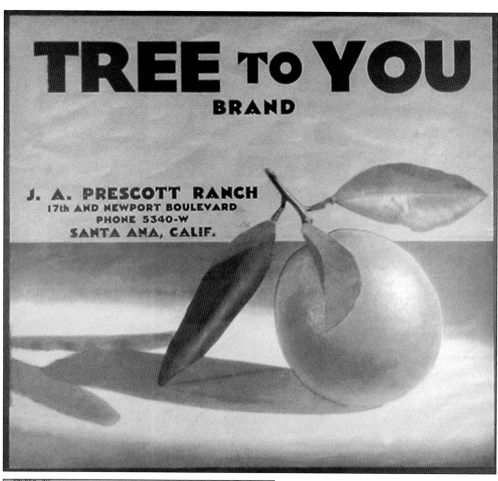

TREE TO YOU BRAND

J. A. PRESCOTT RANCH
17th AND NEWPORT BOULEVARD
PHONE 5340-W
SANTA ANA, CALIF.

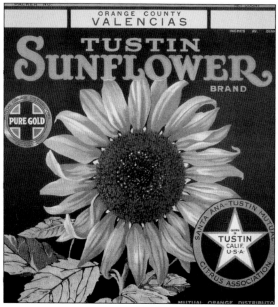

J. A. Prescott Ranch. This was the label for the Tree to You brand of oranges from the Prescott family orchard. The Prescotts still own the remaining farmland at Seventeenth Street and Newport Avenue and presently lease it out for ground crops. (Courtesy Tustin Area Historical Society.)

Santa Ana-Tustin Mutual Citrus Association. This organization of growers started in 1923 and was originally located in Santa Ana. They moved their packinghouse to a location next to the Tustin train station on Newport Avenue. Other brands included Cal-Oro, Tustana, Silver Tips, and Tustin Goldenrod. (Courtesy Tustin Area Historical Society.)

MARCY RANCH. Seven Hills brand was one of many brand names of citrus fruit from this very large grower. Others included Admiral, Navy Greatest, and Officer. (Courtesy Tustin Area Historical Society.)

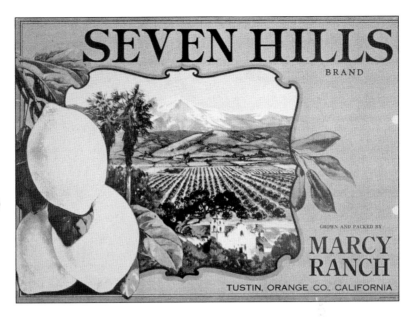

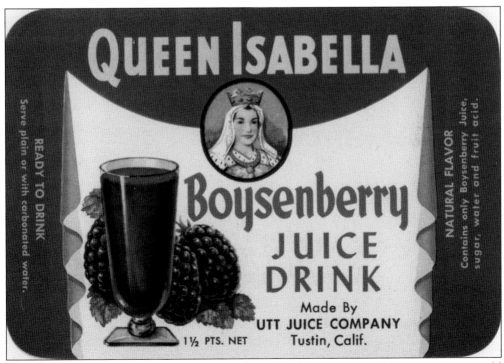

UTT JUICE. This homegrown juice company located at Main Street and Prospect Avenue sold many different varieties of fruit juices, jellies, and other preserves, including those made from the juice of boysenberry, apricot, blackberry, and even gooseberry. Utt was also one of the early producers of pomegranate juice. The company bottled many juices and jellies for Knott's Berry Farm. (Courtesy Tustin Area Historical Society.)

TUSTIN HILLS CITRUS ASSOCIATION. In 1910, this association built its packinghouse between Newport and Holt Avenues, north of Irvine, next to the Tustin/Central Lemon Association. As with most packinghouses, it was located next to a railroad spur—in this case, the Southern Pacific line from Orange. Their brand names included George Washington, Martha Washington, Ranger, and Hill. (Courtesy Tustin Area Historical Society.)

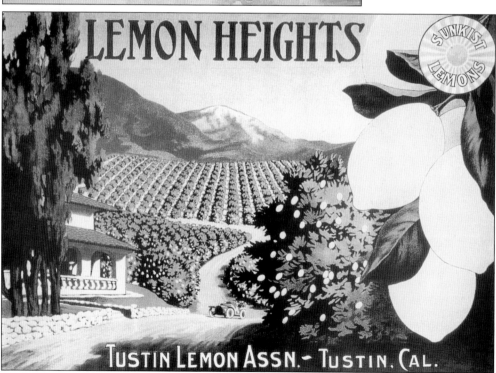

TUSTIN LEMON ASSOCIATION. This large group of growers eventually joined with the Central Lemon Association of Orange to become one of the largest exclusive lemon plants in the world. The Tustin packinghouse was located between Newport and Holt Avenues, north of Irvine, next to the Tustin Hills Citrus Association. (Courtesy Tustin Area Historical Society.)

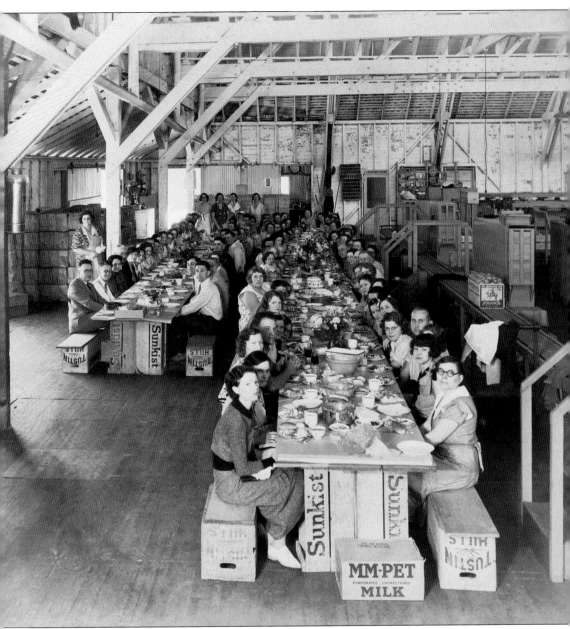

One Mega Potluck. Members, family, and workers of the Tustin Hills Citrus Association held an annual potluck luncheon at their packinghouse on Newport Avenue. Founded in 1909, the association was very successful over the years, expanding their packinghouse and cooling facility several times. However as agricultural land shrank in Tustin and Orange County, the group dissolved in 1963. (Courtesy Tustin Area Historical Society.)

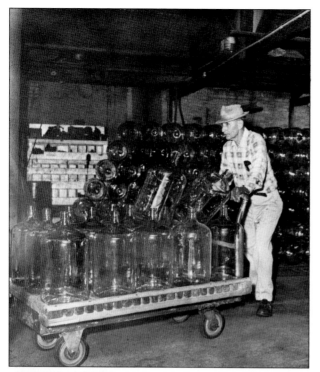

REFILLABLE BOTTLES. Shown in the 1970s photograph at left, Utt Juice employee Frank Bose is carting 5-gallon bottles from the sterilizer to be filled with delicious fruit juices. The larger bottles were sold to commercial customers who would rebottle the products at their facilities. Utt juices, with their brand name of Queen Isabella, were renowned for their flavor and freshness. Below are some of the bottling and conveyor systems in the juice factory. (Courtesy Tustin Area Historical Society.)

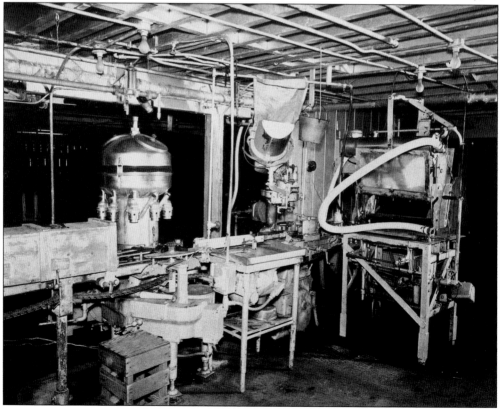

Four

MID-20TH CENTURY

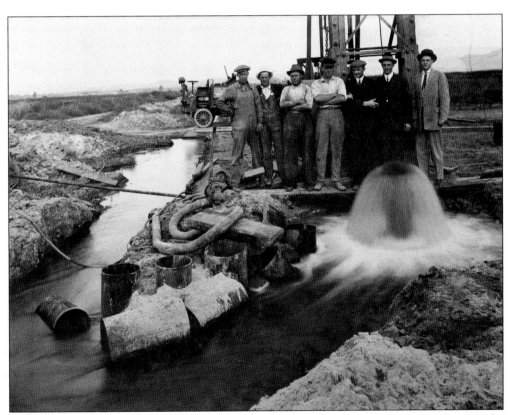

CRITICAL WATER FOR HOMES. Early settlers depended on their own wells to provide water for domestic needs, but in 1887 the Willard brothers and Henry Adams formed the first company to provide piped-in water to Tustin homes. C. E. Utt bought the business in 1897 and owned it until 1982 when the City of Tustin acquired it. This photograph dates to about 1945, when a newly drilled well brought in additional water to help with the water needs of a growing Tustin community. (Courtesy Tustin Area Historical Society.)

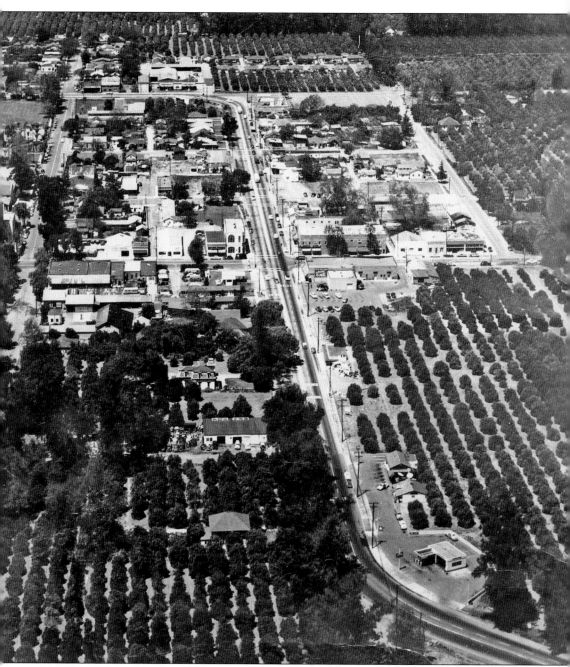

OLD TOWN TUSTIN. In this 1940s photograph, State Highway 101 stretches through the core of downtown Tustin. Starting from the bottom of the photograph, D Street (renamed El Camino Real in 1968) runs north to a curve where it meets up with First Street, heading west toward Santa Ana. In the middle, the intersection of Main Street is identifiable by the light-colored "Bank of Tustin" building at the corner of Main and D Streets. Notice the Samuel Preble house and property, to the left of D Street, where Jamestown Village was eventually built. El Camino Plaza eventually replaced the orchard at the lower curve of D Street, and the first movie theater in Tustin was built there. (Courtesy Tustin Area Historical Society.)

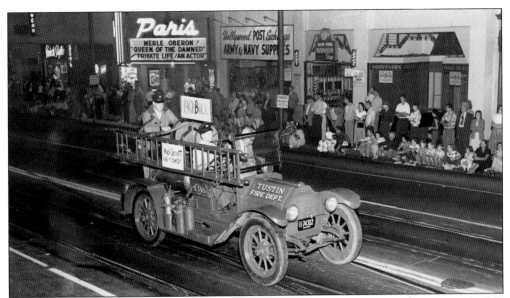

Tustin Goes to Hollywood. In this photograph from the 1950s, Tustin Fire Department's 1912 Buick-turned-fire truck chauffeurs comedy producer Max Sennett during the annual Hollywood parade. Sennett was famous for his innovative slapstick comedies of the early 1910s and 1920s that featured wild car chases and custard pie battles. (Courtesy Tustin Area Historical Society.)

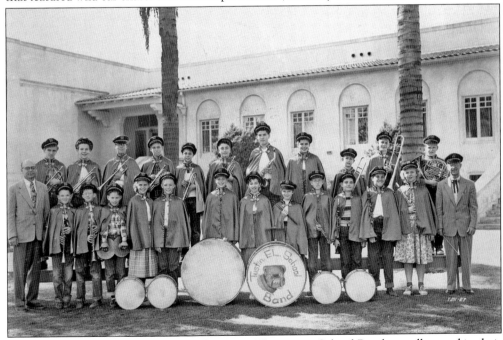

Ready for a Parade. Shown here is the Tustin Elementary School Band, proudly posed in their capes and hats, instruments at the ready. This photograph dates to about 1953. Principal W. R. Nelson is at the far left. W. R. Nelson School was later named for him. On the far right, holding the bandleader's baton is Henry White, a well-respected music teacher. For many years, Tustin Elementary School was the only local school for students up to eighth grade. Students traveled to Santa Ana or Orange for high school grades. (Courtesy Tustin Area Historical Society.)

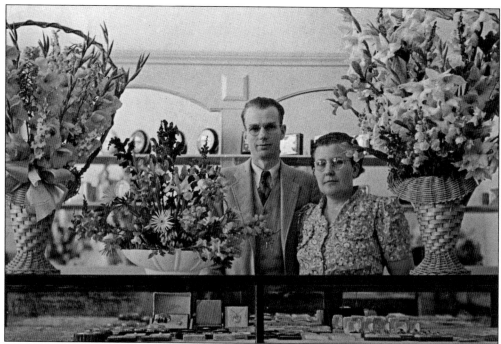

New Store in Town. Albert Farnsworth and his wife are seen posing at the 1941 grand opening of Farnsworth Jewelry Store, located at 130 East Main Street in the Cox Building. A jewelry store had previously been established in that location during the 1920s by Albert F. Hibbet and his wife. (Courtesy Tustin Area Historical Society.)

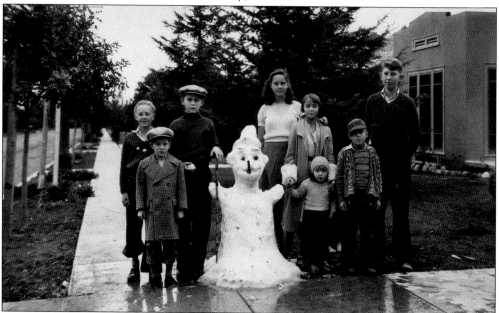

Snow in Tustin. In a very rare day on January 11, 1949, it was cold and wet enough for snow. Though it melted quickly, there was enough snow for at least one snowman. Here children proudly show off their talents at the home of Leonard Schwendeman, located at Main and Pacific Streets. (Courtesy Tustin Area Historical Society.)

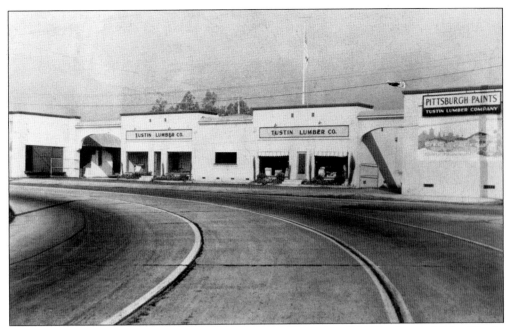

BEFORE HOME DEPOT. Tustin had its first lumberyard in 1910 when S. E. Tingley established Tustin Lumber on East Main Street near the Southern Pacific Railroad depot on Newport Avenue. In 1926, Tingley moved to a larger location on the curve where D Street connected with First Street, shown above. In 1931, the company became Whitson Lumber, a branch of a Santa Ana lumber company. Until the lumberyard closed and the building was torn down in 1993, the business name changed a few more times. This curve would eventually be straightened. (Courtesy Tustin Area Historical Society.)

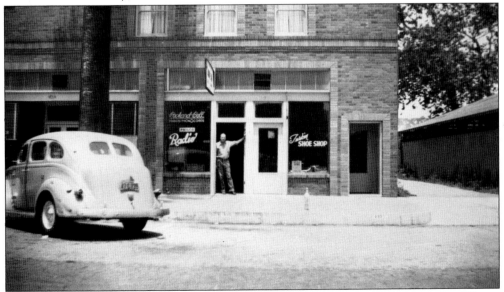

QUALITY FOOTWEAR. In this *c.* 1948 photograph, Ralph Lindsay stands in the doorway of Tustin Radio, next door to his Tustin Shoe Shop. The stores were located on the north side of Main Street at the rear of the Knights of Pythias building. Lindsay was also the fire chief in 1960. (Courtesy Tustin Area Historical Society.)

POLICE AND FIRE BULLETIN NO. 1

Tustin Police Dept. & Volunteer Fire Dept.

TUSTIN, CALIF., December 12, 1941.

This is to notify the citizens of Tustin and the Tustin community of the signals that will be used in the future for Air Raids and Black Outs.

- FOR AIR RAIDS AND BLACK OUTS—Two blasts of Fire Siren at 30-Second Intervals.

 One Blast, All Clear Signal.

- FROST WARNING SIGNAL—Three Blasts of Siren at One-Minute Intervals.

- FIRE WARNING SIGNAL—One Continuous Blast.

> IN CASE OF BLACK OUTS all citizens are hereby requested to remain at home and TURN OUT ALL LIGHTS, and if any lights are burning in your community please request that lights be extinguished and REMAIN IN DARKNESS UNTIL THE CLEAR SIGNAL IS SOUNDED.

This Is For Your Protection--Please Cooperate

All Firemen are Official Black Out Fire Wardens and have the authority to enforce same.

Signed:

J. LeROY WILSON, Mayor.

JOHN L. STANTON, Chief of Police.

E. L. KISER, Chief of Fire Dept.

WARTIME ALERT. This flyer is a reminder of just how serious threats of attacks during World War II were taken. Distributed just five days after the devastating attack on Pearl Harbor, the country wasn't sure if an attack on the west coast was imminent or not. As close as Tustin was to the ocean, the city's leaders weren't taking chances. They used the existing frost and fire siren to warn residents in case they needed to black out their homes. (Courtesy Tustin Area Historical Society.)

LARGE CONSTRUCTION PROJECT. Once final design planning was approved in 1942, the race was on to build the two blimp hangars at the Naval Air Station Santa Ana, called that because the location of it was officially unincorporated county territory. Working nine-hour days, seven days a week, workers built the first 17-story-tall hangar in nine months. (Courtesy Tustin Area Historical Society.)

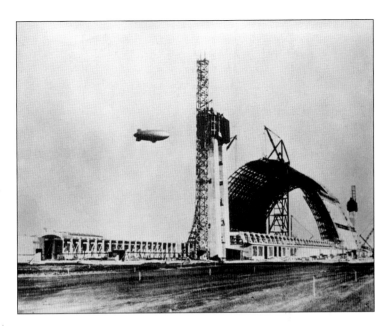

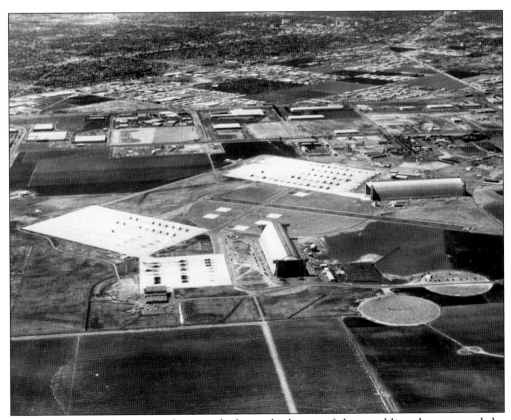

BASE OVERVIEW. This 1960s photograph shows the layout of the two blimp hangars and the general base configuration. (Courtesy Tustin Area Historical Society.)

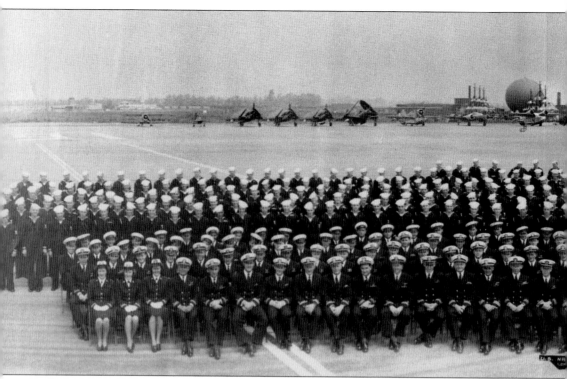

READY FOR ACTION. The Naval Air Station Lighter Than Air (LTA) command, support, and crew proudly posed in dress uniforms to mark full operation in 1943. The base was quickly brought into service after World War II began in order to support the blimps, which were used to patrol America's coastline—primarily to watch for enemy submarines. The Tustin base was crucial to U.S. Navy and,

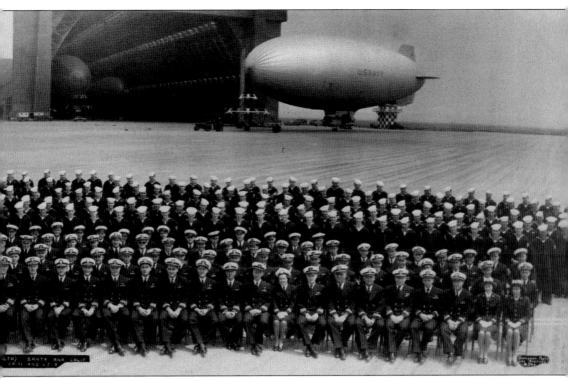

later, U.S. Marine aviation for 50 years, playing a critical role in every major American military operation from 1942 to 1992, including World War II, Korea, Vietnam, and Operation Desert Storm. Initially an LTA airship base, the station eventually became the principal helicopter facility in the Pacific region for the U.S. Marine Corps aviation's division. (Courtesy Tustin Area Historical Society.)

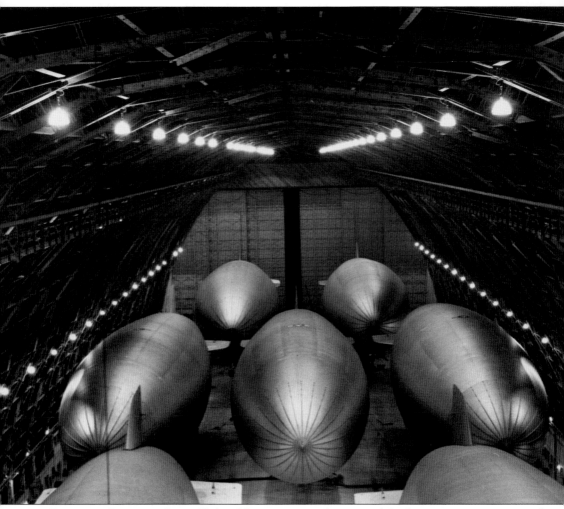

FILLED TO CAPACITY. Seven K-class blimps are stored in one of the hangars sometime around 1942. The blimps, which were 250 feet long and 57 feet in diameter, were used for anti-submarine detection and warfare. All the equipment was carried underneath in a 40-foot-long control car. The blimps were operated by a crew of 10, carried four depth bombs, and had a 50-caliber machine gun. (Courtesy Tustin Area Historical Society.)

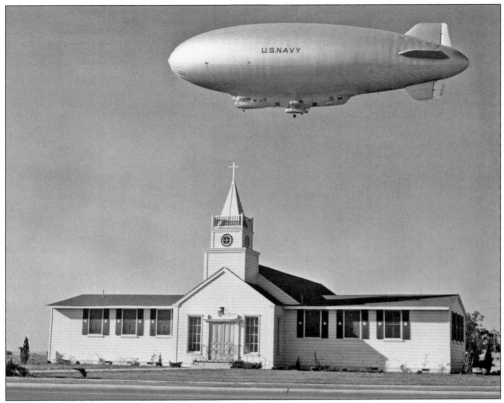

Flyby. In this photograph, taken around 1944, a U.S. Navy airship passes over the base chapel. The naval air station was developed on 1,400 acres purchased from James Irvine in 1942. Base operations began six months later, with construction of both hangars completed in 1943. (Courtesy Tustin Area Historical Society.)

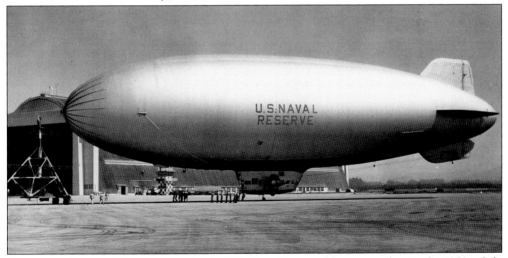

Ready for Action. This photograph of a U.S. Naval Reserve blimp was taken in the 1950s while the crew was readying it for flight. During that time, the crew would practice their shooting skills by dropping targets toward the ocean and firing on them with their 50-caliber machine guns. (Courtesy Bill Greene.)

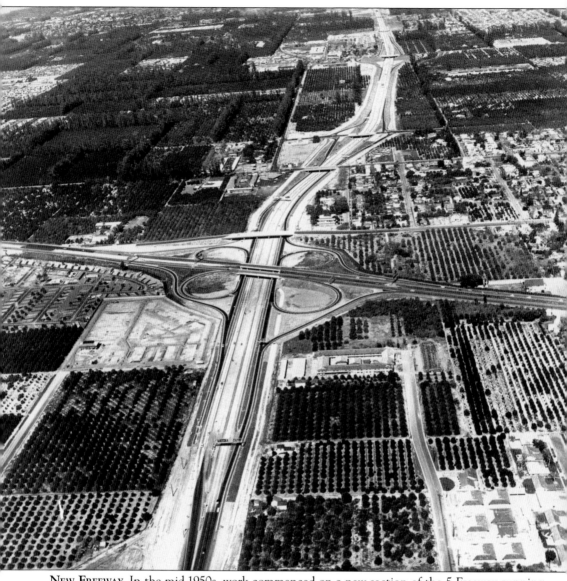

NEW FREEWAY. In the mid-1950s, work commenced on a new section of the 5 Freeway running south from Santa Ana towards El Toro. Work also soon began on the 55 Freeway towards Corona. The photograph above dates to about 1963 and shows the completed construction. Unfortunately the freeways cut a wide swath through Tustin, taking away a number of older homes and splitting productive groves. In addition, the diversion of traffic away from the existing Highway 101 and the main Tustin business district also hurt many local stores, gas stations, and motels that depended on the flow-through traffic for business. (Courtesy California Department of Transportation.)

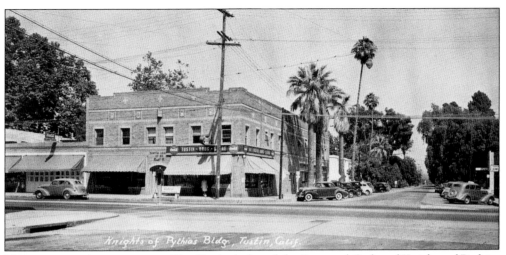

NEOCLASSICAL ARCHITECTURE. The Tustin lodge of the Fraternal Order of Knights of Pythias was chartered in 1882 and grew to be an important civic and fraternal organization of Tustin area residents. In 1925, the Order purchased the property at the corner of D and Main Streets and constructed the two-story gold and brown brick building still standing. The lodge continues to occupy the second floor with the first floor designed for businesses. The building has seen many tenants including the first city hall, the post office, a variety store, drugstores, and currently the Tustin Area Museum and i.initial store. (Courtesy Tustin Area Historical Society.)

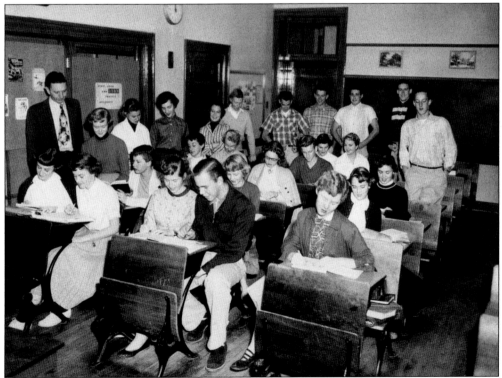

FUTURE JOURNALISTS. The staff of Tustin High School's *Broadcaster* meets in 1955 for a yearbook photograph. Teacher John Veeh, left, supervised the biweekly publication, which brought news, sports, events, and "farmer's fables" to the student body. (Courtesy Tustin Area Historical Society.)

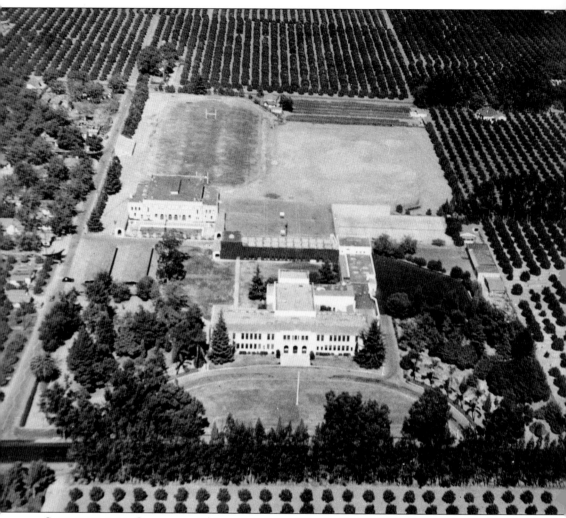

SURROUNDED BY ORCHARDS. This aerial view of Tustin Union High School shows the school mostly surrounded by fruit orchards during the 1940s and early 1950s. Orange Street can be seen to the left of the school grounds. In 1966, it was decided that the main building was not earthquake safe, so it had to be rebuilt. To the testament of the quality of the original construction, it took wreckers 10 days to demolish the building. (Courtesy Tustin Area Historical Society.)

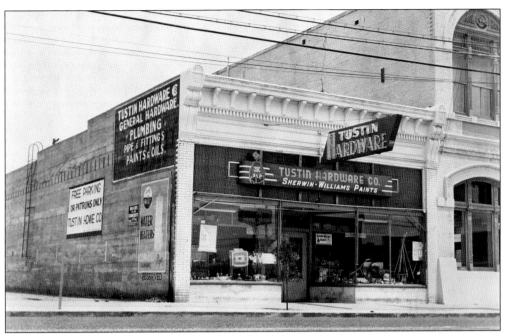

HOMETOWN HARDWARE STORE. Tustin was, and still is, blessed with a few truly local hardware stores, and Tustin Hardware was one such community mainstay for almost 87 years. They not only stocked all sorts of necessary widgets and key parts for orchard and home needs, but the store also served as a community meeting place. Men often relaxed and enjoyed the companionship of friends after a long day at the rear of the store with its battered chairs and benches circled around a potbellied woodstove. The store was adjacent to the First National Bank of Tustin. The hardware business closed in the late 1990s but the storefront reopened in 1999 as Mrs. B's Consignments Etc., specializing in vintage antiques and other unique items. (Courtesy Tustin Area Historical Society.)

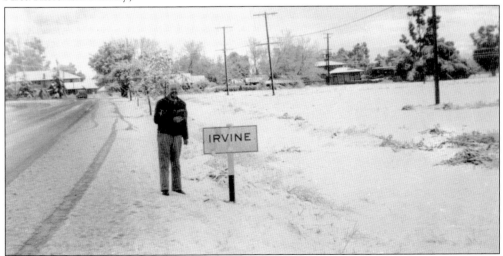

A CHILLY JANUARY DAY. The storm of January 1949 brought more than a little snow for snowmen. Crops were damaged by the very unusual cold snap. Here Paul Andres is standing at the Irvine town line on Highway 101 near where Sand Canyon is today. (Courtesy Tustin Area Historical Society.)

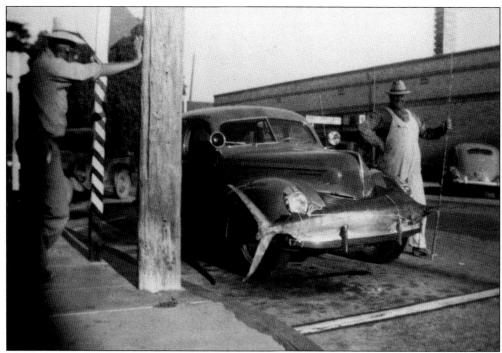

Big Fish Story. A very proud police chief, "Big John" Stanton, shows off his just-caught marlin bluefish that is tied to the police car. The location of this photograph is Main and D Streets, sometime around 1940. (Courtesy Tustin Area Historical Society.)

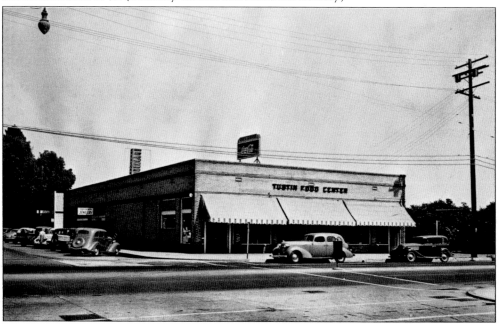

Cox's Market. The Tustin Food Center was originally built for Continental Stores, a grocery with locations in several towns. Edwin and Leola Cox constructed the building and operated Cox's Market and Tustin Food Center there for almost 30 years. The building has stayed in the family and is currently home to several specialty stores. (Courtesy Tustin Area Historical Society.)

Five

THE CHANGING CITY

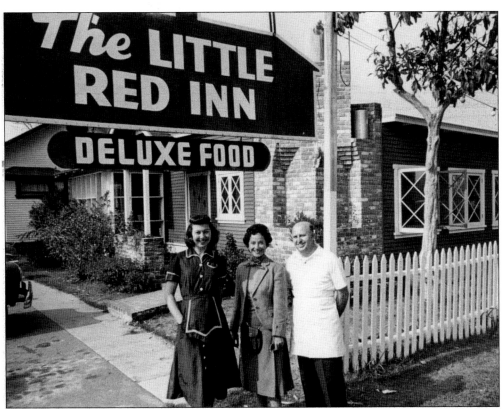

DRESS CODE REQUIRED. Hollywood actress Merle Oberon, center, (*The Scarlet Pimpernel* and *Wuthering Heights*) takes a break to enjoy a meal at The Little Red Inn during the 1950s. She is pictured in this photograph with chef Al Pauck and his wife, Fran, restaurant owners and managers. The well-loved restaurant, located on Laguna Road, was considered "classy" for the area and required men to wear jackets and women to don their Sunday best. (Courtesy Tustin Area Historical Society.)

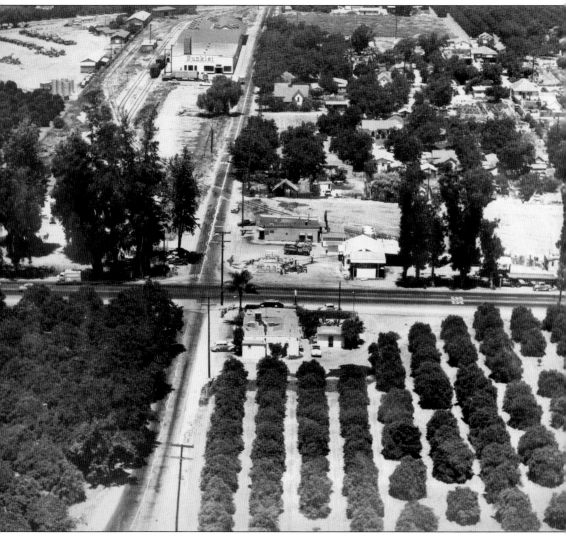

Temporarily Still a Rural Tustin. Visible from this viewpoint in the 1950s is the intersection of horizontally running Laguna Road (now El Camino Real) crossing Newport Avenue. At the top left are the train tracks alongside the packinghouse of the Santa Ana-Tustin Mutual Citrus Association. In an 1880 county plat map, Newport Avenue was then called Newport Landing Road due to the eventual destination of the road to the beach. To the far right of the intersection—just out of frame—is the Tustin High School. (Courtesy Tustin Area Historical Society.)

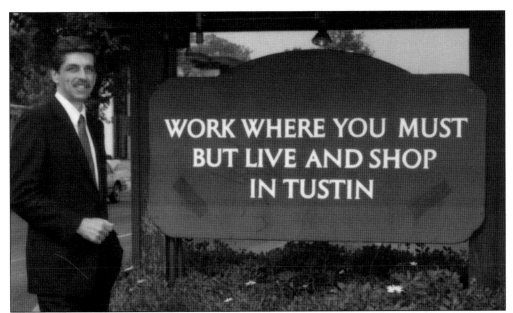

WELCOME. In the late 1960s, then mayor A. J. "Tony" Coco stands behind one of the "Welcome to Tustin" signs at the entrances to the city. He recalls that as he was leaving town to go to work one morning, he came up with the idea of adding the phrase "Work where you must but live in Tustin" to an otherwise blank rear panel on the sign. "I ran the idea by Frank Greinke, then president of the Tustin chamber, who pointed out that our local merchants were not included. So I modified the words to add just two words, 'and shop,' and for the last 40 or so years the message has endured." (Courtesy Anthony Coco.)

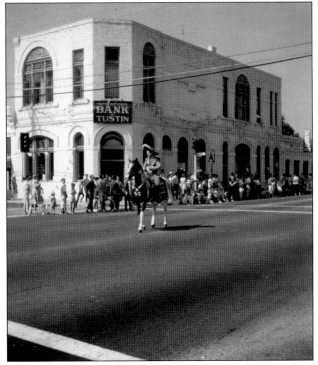

MAIN STREET PARADE. The Tustin Tiller Days celebration is a beloved annual event that gives many Tustinites a real, small-town celebration of the city's agricultural roots. The event was started in 1957 by the chamber of commerce and the *Tustin News*—particularly Bill Moses, editor of the newspaper. At that time, the parade ran only a short distance on D Street with community booths located on a closed-off section of Main Street. (Courtesy Tustin Area Historical Society.)

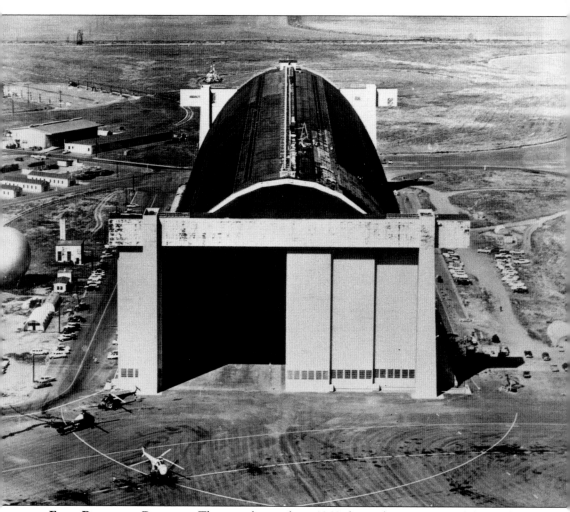

FROM BLIMPS TO CHOPPERS. This aerial view from 1960 shows the active use of the facility for U.S. Marine Corps helicopter functions. The base was decommissioned in 1949 and was used as a civilian airfield, air museum, and blimp storage until 1951 when the corps recommissioned the base for the Korean War. In 1978, two years after the base had been annexed by the City of Tustin, the city's name was finally added to its title: Marine Corps Air Station Tustin. The base was permanently closed in July 1999. Of the approximate 1,600 acres, approximately 1,294 acres have already been conveyed to the City of Tustin, private developers, and public institutions for a combination of residential, commercial, educational, and public recreational and open-space uses. Current plans call for the demolition of the city-owned blimp hangar. The fate of the other county-owned hangar is still under discussion. (Courtesy Tustin Area Historical Society.)

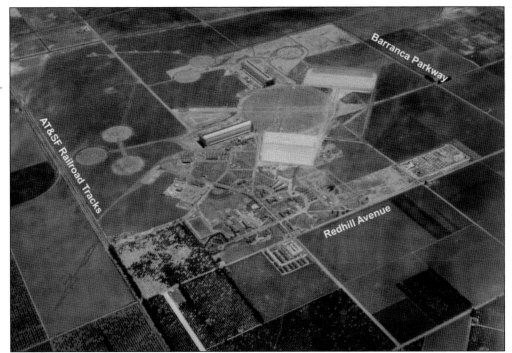

BEFORE TUSTIN MEADOWS. This aerial view of the Marine Corps Air Station Tustin dates back to the early 1960s. The area around it—including the future Tustin Meadows neighborhood and the industrial park west of Redhill—was, at the time, simply orchards and farmland. Originally laid by the Atchison, Topeka, and Santa Fe Railroad (AT&SF) to help transport local produce to national markets, the railroad tracks were sold to Metrolink for their commuter service. Burlington Northern Santa Fe still uses them for freight lines. (Courtesy Tustin Community Redevelopment Agency.)

BROADMOOR HOMES. Tustin home builder Richard B. Smith's Broadmoor home development, located between Mitchell and Walnut Avenues, was designed in a modern style with architectural touches like bold horizontal lines, glass-walled atriums, and recessed entries. The purchase of one of his 127 homes in central Tustin included use of a private park and a community pool complex named The Cabana Club. When model homes opened on May 5, 1968, the news was the lead story of the Los Angeles Times's real estate section, and houses quickly sold out. (Courtesy Kathy Hall.)

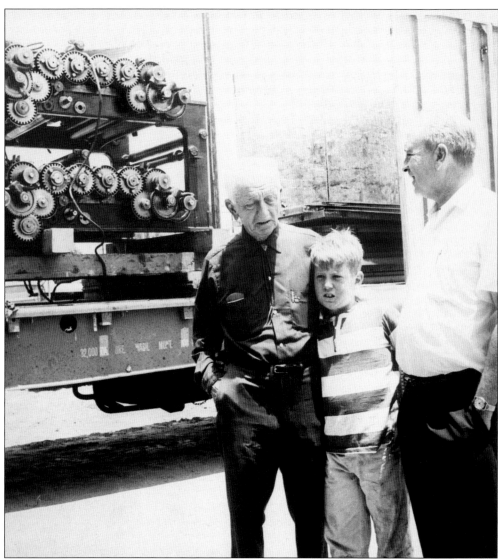

Very Local Newspaper. The *Tustin News* has graced the doorsteps of residents for more than 89 years, currently continuing as a weekly edition in conjunction with the *Orange County Register*. The newspaper was started in 1922 and was bought and sold by eight other owners until 1956 when William "Bill" Moses II, right, and his wife, Lucille, purchased the paper. For the next 39 years, they grew the paper into an indispensable part of Tustin life. Moses also worked on a variety of community projects to better the city, such as sparking the first Tiller Days celebration and fighting for an off-ramp from the 5 Freeway at Newport Avenue. Deciding to retire, the Moseses sold the *Tustin News* to the *Orange County Register* in 1995. Pictured with Moses in this 1966 photograph are his father, William, and his son William. (Courtesy Tustin Area Historical Society.)

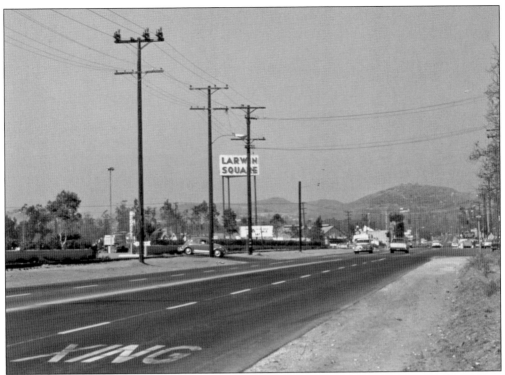

EARLY NEWPORT AVENUE. Back in 1966, Newport was a simpler road with a variety of stores, gas stations, surviving packinghouses, little traffic, and space between businesses. Larwin Square at First Street was one of a few multiuse shopping areas in the growing city. In the next decade, all of that changed, as Tustin's population doubled and tripled and Newport became a major commercial thoroughfare. (Courtesy Orange County Archives.)

A TREE WITH A HISTORY. In the early 1980s, Art Vandenberg sold a large parcel of land between Seventeenth Street and Vandenberg Lane for commercial use. One of Vandenberg's conditions was that the existing camphor tree, seen at right in 1981, would not be cut down. The Oak Tree Shopping center was constructed and surrounding the tree is a patio table area for the center's restaurants. (Courtesy Jeffrey Williams.)

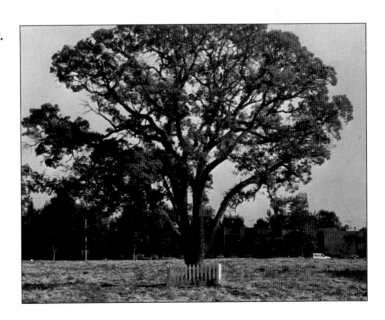

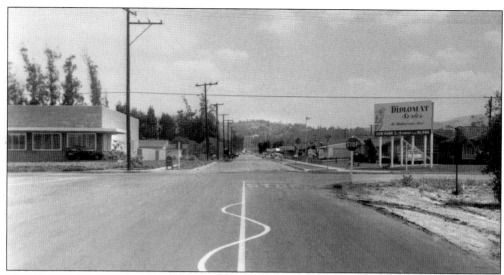

NEW HOMES. The population of Tustin started to boom in the 1960s as land that was previously used for orchards became new residential developments. This photograph from that time period shows Browning Avenue at Irvine Boulevard. The sign for the Diplomat Series development claims to be "the thinking man's home" with prices starting at $21,400. (Courtesy Orange County Archives.)

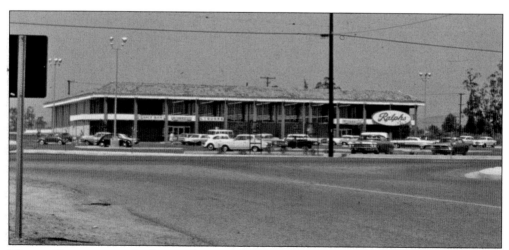

MODERN SUPERMARKET. As the population in the Tustin area grew, food supermarkets sprung up to support the new residents. This Ralphs market, located on Seventeenth Street at the intersection of Yorba Street, is shown in 1966 and was the neighborhood store for many in the north Tustin area. Years later, Ralphs relocated to Irvine Boulevard. (Courtesy Orange County Archives.)

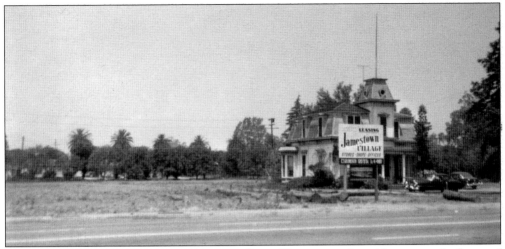

BEAUTIFUL HOME OF A PIONEER. This magnificent Victorian-style residence was the home of George Preble, who came to Tustin in 1876. A builder as well as an orange grower, Preble built the Tustin Hotel and the original Tustin High School in addition to this house. The property was purchased by builder C. T. Gilbreath, who lived in the house until 1960 when work began on Jamestown Village. Though Gilbreath offered the structure free to anyone who would move it, the house was demolished in 1960 when work began on the center. (Courtesy Spencer Gilbreath.)

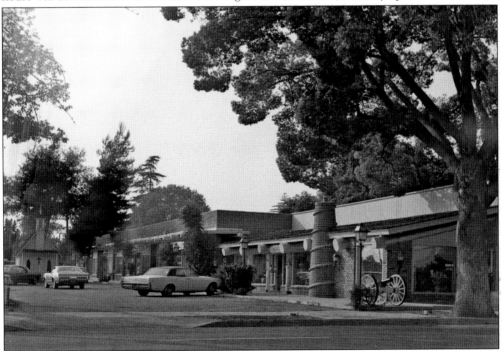

A NEW BEGINNING. Jamestown Village was designed to offer a homey approach to the new shopping centers popping up in post-agricultural Tustin. Builder C. T. Gilbreath kept many of the trees on the original property and figured out a way to design around an existing oak tree in the center's parking lot. He added a smaller replica of his grandmother's church in Tennessee around a tree that grew out of the roof. The tree has since died but the Little Tree Church remains. (Courtesy Tustin Area Historical Society.)

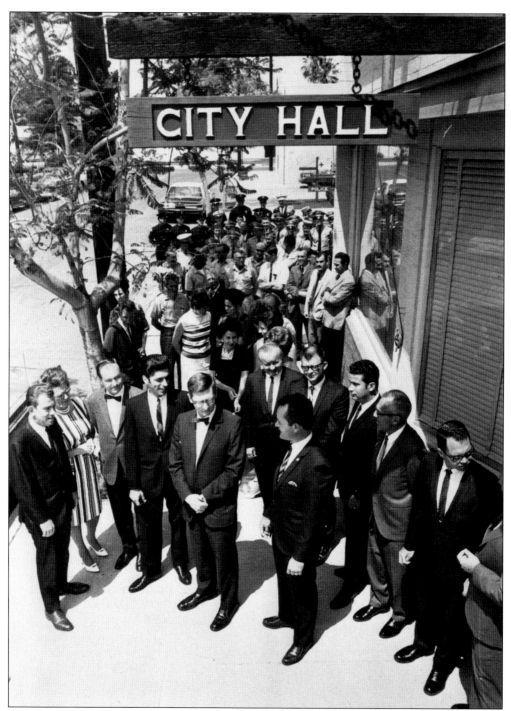

CITY HALL FOR A GROWING CITY. City councilmen and employees gathered for this photograph in 1968 in front of city hall, which was then located on Third Street. By 1974, the city outgrew this facility and moved to the current city hall complex on Centennial Way, which included the Tustin Library and a community room. The complex expanded in 1993 to keep pace with the city's growth. (Courtesy Tustin Area Historical Society.)

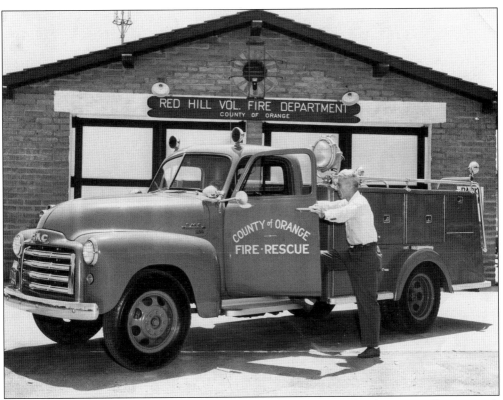

READY TO ROLL. Chief Duke Suddaby stands at the door of the Red Hill Volunteer Fire Department's first vehicle, a 1950 GMC rescue and salvage truck. Local residents formed the volunteer force in 1948 to improve the response to emergencies in the northeast area of Tustin. For more than 40 years, locals trained and volunteered to help their neighbors. In 1999, the county eliminated the volunteer program in favor of full-time, paid firefighters. But the memories and appreciation of the volunteers are not forgotten. In the photograph below, local residents visit the fire station in the 1960s during an annual open house event. (Courtesy Carol Garner.)

EARLY POLICING. In the early 1980s, Tustin police dispatchers had all the latest equipment: push-button telephones, IBM Selectric typewriters, reel-to-reel tape recorders, and a newfangled computer. Scottie Frazier, left, identifies a location on an officer-designed drum map created to give dispatchers quick views of the expanding city limits. Diana Brantner, right, manually types one of many reports a dispatcher would have to complete during the course of their day. Frazier recently retired from the force after 37 years of serving the residents of Tustin. (Courtesy Scottie Frazier.)

ALL MIMSY WERE THE BOROGOVES. In the late 1950s and 1960s, the Jabberwocky on D Street housed a teenage fashion shop. Originally constructed in 1885 for the office of Dr. James Sheldon, Tustin's first physician, the building is used today as The Vintage Lady, a gift and garden shop. (Courtesy Tustin Area Historical Society.)

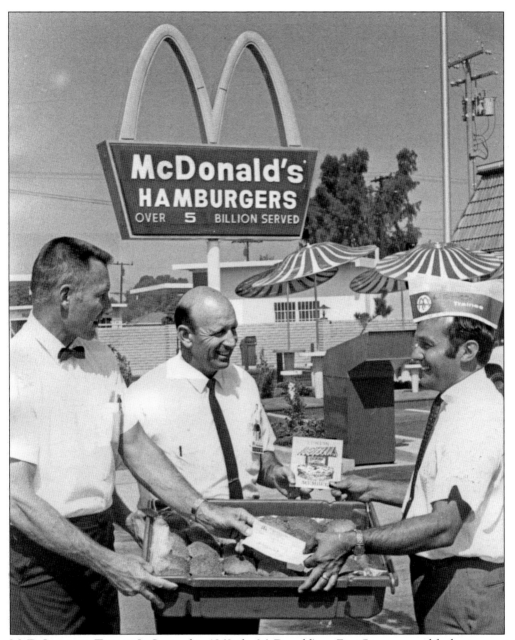

McD Comes to Tustin. In September 1969, the McDonald's on First Street opened for business as one of the earliest fast food restaurants in the city. Owners Gordon Gray and "Speed" Shuster speak to trainee Frank Greinke—who, at the time, was actually president of the chamber of commerce. Note how many hamburgers have been served, according to the sign; today it is estimated that over 245 billion have been served. (Courtesy Tustin Area Historical Society.)

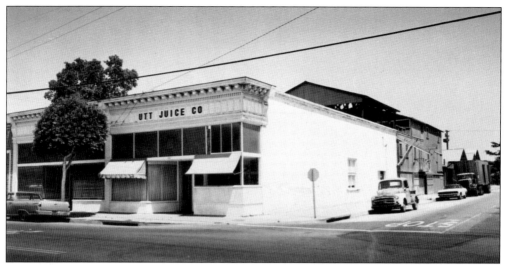

HOMEGROWN JUICES. The Utt Juice Company was known throughout the west not only for their delicious juices but also for their flavorful jams, jellies, and syrups. Utt used crops from local orchards, including his, to manufacture products at this building and in the large factory behind it. In 1931, Utt sold the juice company to Arcy Schellhous, his business partner. The company closed in 1973, and the building lay vacant for years. In 2008, a new live/work mixed-use development called Prospect Village replaced the remaining building. (Courtesy Tustin Area Historical Society.)

EARLY CITY CENTER. In the first years after the city's incorporation in 1927, city hall was located in the Knights of Pythias building on Main Street. When the first fire engine house, shown above in the mid-1950s, was constructed in 1931 on Third Street, some city staff moved to offices there. The building was expanded in 1950 and housed all city departments, including police, city hall, courts, and the library, under one roof until 1965 when city growth forced some departments to move out. (Courtesy Tustin Area Historical Society.)

STRONG COMMUNITY TRADITION. Tustin has always valued its library, even when it was only a small room in the old, Victorian schoolhouse of the 1890s. Over the years, the library was located in a variety of locations including a room in the back of the First National Bank of Tustin and, in the 1950s, in an annex next to the fire station on Third Street. The photograph above shows the first brand-new building the library ever moved into, located at Newport Avenue and Andrews Street in 1958. The library moved to a larger civic center location in 1976. Last year, the Tustin Branch Library proudly moved to its 32,000-square-foot, custom-designed facility. The expansion allows the library to offer modern technology services and features an expanded room for the book collection. The building shown above is now home to a bagel shop and a preschool. (Courtesy Tustin Area Historical Society.)

FIRE POWER. Tustin fire chief Morgan Hilton proudly shows off one of his newest fire engines to a troop of Boy Scouts in 1966. (Courtesy Tustin Area Historical Society.)

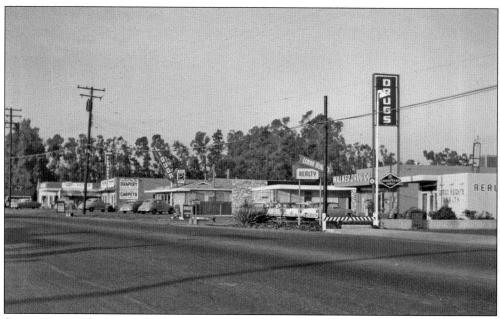

SMALL SHOPS. This group of stores and a realty office in the 1960s was located on the east side of Tustin Avenue just north of Seventeenth Street. Today it is generally an open field waiting for development. (Courtesy Orange County Archives.)

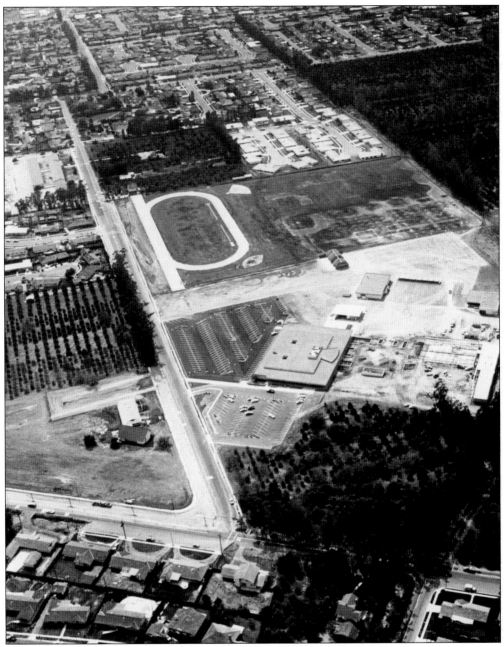

TUSTIN'S SECOND HIGH SCHOOL. Foothill High School opened in 1963 to support a growing student population that was mainly in the northern part of the Tustin school district. This area of incorporated Tustin and unincorporated county territory saw a huge increase in population as farmland was developed for residential use. The school's name is derived from its location at the base of Cowan and Lemon Heights in North Tustin. (Courtesy Tustin Area Historical Society.)

FROM DIRT TO STORES. Today Enderle Center on Seventeenth Street is well known for having unique stores and renowned restaurants. In 1976, the vacant ground became part of a 15-acre specialty retail complex. The project was part of a large Enderle family orchard pioneered around 1900 by Herman Enderle, his brother Frank, and sister Rose. In 1971, the family was involved with the successful Enderle Gardens, a relatively new concept of homes with shared common lawns and park areas. A few years later, Al Enderle, grandson to Herman, partnered with general contractor Clyde Mitchell and architect Jim Schimozono to build the premiere shopping center. In the photograph above, from left to right, Al's oldest son, Rob, matriarch Harriet Enderle, Al, and Geri Enderle participate in the ground-breaking. The center is also well known for the Enderle Center Car Show, founded in 1999. The annual show features hundreds of classic and customized cars, and the proceeds benefit local charities. (Courtesy Al Enderle.)

Six

MODERN MEMORIES

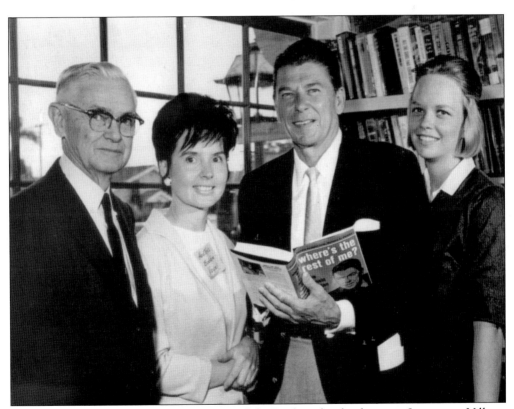

ACTOR REAGAN. Actor Ronald Reagan visited the Bookmark, a bookstore in Jamestown Village, on May 4, 1965, to sign copies of his new autobiography. The following year, Reagan was elected governor of California, then was reelected four years later. In 1980, he was elected president for the first of two terms in office. From left to right in this photograph are Walter Knott, founder of Knott's Berry Farm; Barbara Vogel, owner of the Bookmark; Ronald Reagan; and Maureen Reagan. (Courtesy Dr. Hans Vogel.)

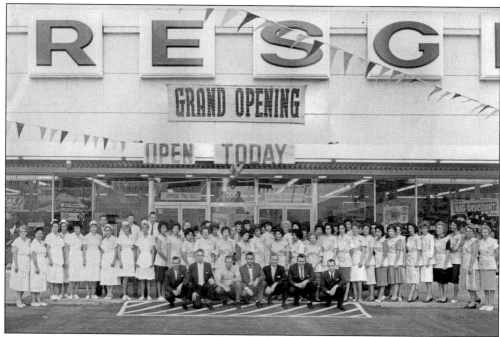

DISCOUNT PRICES. S. S. Kresges, one of the country's large discount department stores, opened at Larwin Square in the 1960s to serve a growing population in Tustin. The store would later restructure, become a K-Mart, and move from this location. Residents remember the lunch counter where they could get a bite to eat, especially the delicious grilled-cheese sandwiches. (Courtesy Tustin Area Historical Society.)

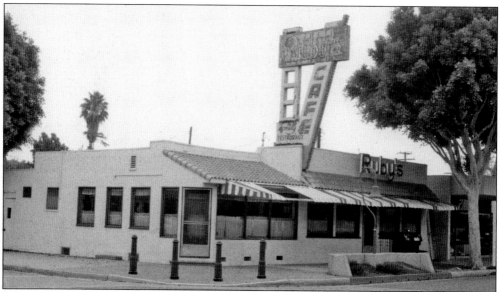

GONE BUT NOT FORGOTTEN. Ruby's Café was a landmark on old Highway 101 until the late 1970s, serving as a favorite truck stop, local meeting place, and haven for growers setting smudge pots on cold winter nights. While many may think this restaurant is part of the current Ruby's Diner chain, it is not. The founder of the Ruby's Diner chains named the restaurant after a very special person: his mom. (Courtesy Tustin Area Historical Society.)

OKLAHOMA. Elizabeth Howard's Curtain Call Dinner Theater opened in April 1980 offering theatrical performances of some of Broadway's best musicals along with the comfort of having a delicious meal served. At the time, there were five such dinner theaters in Orange County and only Elizabeth Howard's survived. She and her husband owned the theater for 25 years and featured more than 100 shows. Today the theater continues under new ownership and is run by an actress who performed in several of Howard's musicals. Prior to 1980, the location was actually a favorite local movie house appropriately named the Tustin Theater. (Courtesy Elizabeth Howard.)

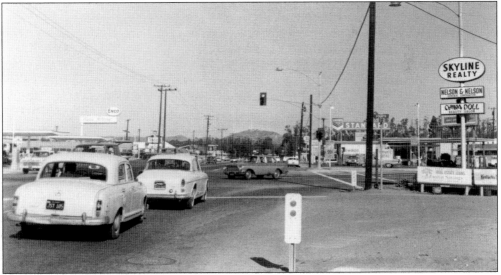

CORNER BUSINESSES. This corner of Newport Avenue and Irvine Boulevard in 1964 is a different view from today. The Standard Oil gas station at right is now the location of a Walgreens Drug Store. Behind the gas station is a sign for the city's early Baskin-Robbins ice cream parlor. Across Newport Avenue is an Enco service station that is now the location for Lafayette Plaza. The only thing still surviving from this picture are the pole signs at the right. The businesses are different but the sign post has stayed the same. (Courtesy Orange County Archives.)

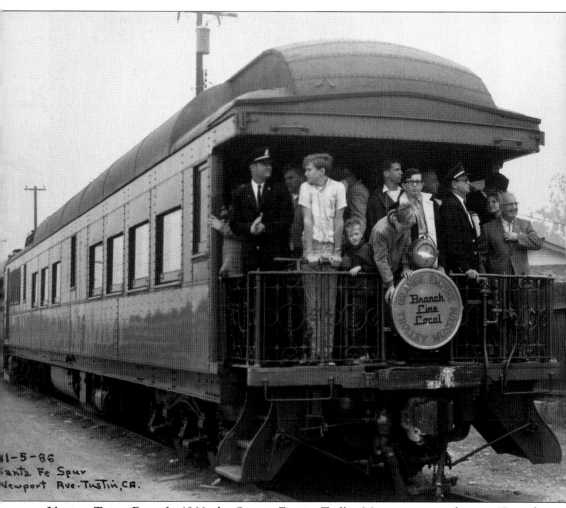

UNIQUE TRAIN RIDE. In 1966, the Orange Empire Trolley Museum arranged a rare "Branch Line Local" train excursion along one of the railroad branches that supported the local citrus packinghouses. This photograph was taken on the Santa Fe Railway line near Newport Avenue at Irvine Boulevard, close to where Ruby's Diner is now. Local resident and longtime train enthusiast Cliff Prather is seen here as a young man with glasses on the deck of this observation car. (Courtesy Tustin Area Historical Society.)

TUSTIN'S BASEBALL LEGACY. In the 1960s, baseball little leagues developed in the growing city. Today Tustin Western and Tustin Eastern, along with Tustin Pony Baseball, continue to help kids enjoy this all-American sport. In the 1970 photograph above, team manager Barton stands at left and coach Dan Nitzen is on the right. (Courtesy David Nitzen.)

FAMILY RUN, FAMILY FOOD. Rod Spurlock's Family Restaurant on D Street was a favorite local spot in the 1960s and early 1970s with an intimate setting and plenty of homemade food created by three generations of Spurlocks. At right are, from left to right, Gary Spurlock, an unidentified customer, and owners Leona and Rod Spurlock. (Courtesy Spurlock family.)

HOPE FOR THE FUTURE. In 1976, the city's bicentennial committee wanted to commemorate the nation's anniversary and invited the community to come up with the idea for a special permanent monument. A young Tustin schoolboy suggested a wishing well to offer good wishes for the future and to serve as a memorial for local soldiers who fell in past wars. The 2010 photograph above shows the monument, located on Centennial and Main Streets. (Courtesy Guy Ball.)

BICENTENNIAL CELEBRATION. Mary Kelly, right, is pictured on July 4, 1976, with her friend Julie Kelly in front of the Tustin Wishing Well. Mary Kelly spearheaded the campaign, along with Susan Moore and Martha Williams, to raise funds to build the wishing well. Note the original brick face of the well. This was covered years later with stucco when the city refurbished the roof and supports. (Courtesy John Kelly.)

A TIME FOR FUN. Members of the Red Hill Volunteer Fire Department would annually perform some sort of skit or routine for residents who lined the route of the Tustin Tiller Days parade in the fall. Here the firemen dress up in their red "union suits" and boots and have a little fun with a mobile outhouse and buckets of water. (Courtesy Carol Garner.)

A REAL TILLER. Participants in the annual Tustin Tiller Days parade always include marching bands, scout troops, elected officials, school cheer squads, community groups, and a contingent of residents who bring out their antique tractors to celebrate the town's agricultural roots. Richard Vining, a parade regular, is shown above on a vintage tractor in the 1993 parade. (Courtesy Tustin Parks and Recreation Department.)

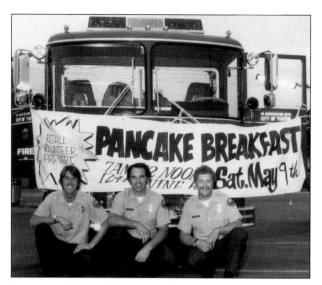

PANCAKE TIME. One of the highlights of late spring was the Red Hill Volunteer Fire Department's pancake breakfast at their station at Irvine Boulevard and Newport Avenue. The men who volunteered their time would put aside their boots and protective gear to serve heaping mounds of hotcakes at their annual open house. Tustin locals from the north end of town would come out to enjoy the breakfast, tour the station house, and give thanks to those who protected them. From left to right are Tim Murphy, John Garner, and Steve Kelso. (Courtesy Carol Garner.)

FAVORITE RESTAURANT. The Barn Restaurant and Saloon on the corner of Redhill and Edinger Avenues was well known throughout central Orange County for its homey atmosphere and great steaks. But for locals from bordering Tustin Meadows, the restaurant was family. When the building was moved from its original location in Irvine during the early 1970s, some local residents actually came out to help finish it for opening night. Sadly times changed and the restaurant closed in the late 1990s. (Courtesy Dietrich Sellenthin.)

FOURTH OF JULY PARADE. The Tustin Meadows community boasts a long-standing tradition of hosting a neighborhood parade and block party every Fourth of July for the last 41 years. These 900 homes began in 1968 on Irvine Ranch land and were bought up quickly by families looking for safe and friendly neighborhoods. The homes are centered around common areas of parks, walkways, and two community centers—a unique concept for the time. (Courtesy Dietrich Sellenthin.)

TUSTIN SON TO THE CAPITAL. Tustin-born Republican congressman James B. Utt (left) is shown here with Vice Pres. Richard Nixon (center) and John Hardy at the Disneyland Hotel in 1961. Utt was first elected to Congress in 1952 and stayed in office until he died in 1970. An unapologetic conservative, Utt had very strong views about the civil rights acts, the United Nations, and voting rights. (Courtesy Tustin Area Historical Society.)

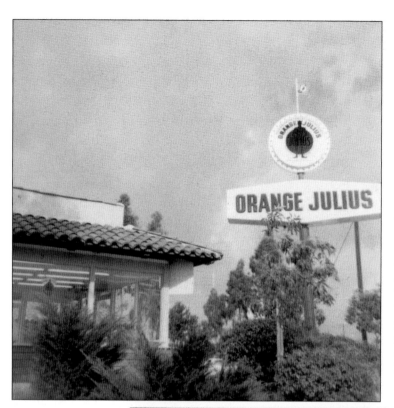

Mmmmm Good. The Orange Julius, located on Newport Boulevard at Walnut Street, was a favorite spot for Tustin teens and families when they wanted a delicious and unique smoothie or a good chili dog. The owners supported local youth by often hiring Tustin High School students as their staff. The restaurant closed in the 1970s, and the building has long been a Mexican restaurant known for its tasty "tacos al carbon." (Courtesy Kathy Hall.)

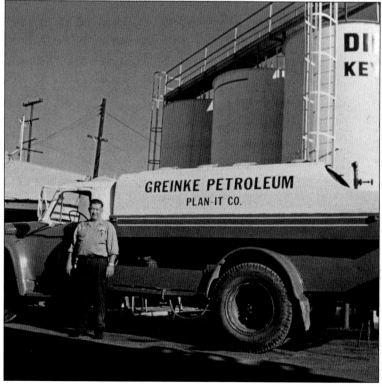

A Family Business that Keeps Growing. Students walking to Tustin High School in the 1960s and 1970s remember the three big storage tanks of Greinke Petroleum that stood at the corner of Newport Avenue and El Camino Real. Frank H. Greinke started the company in 1930, and it has grown to become one of the largest petroleum wholesalers in the West. Longtime employee Woodrow Perry is shown at right beside his truck. (Courtesy Margaret Greinke.)

ENCOURAGEMENT TO RUN. The annual Dino Dash, a fund-raiser during which local students and their family members run and walk, celebrated its 20th anniversary in 2010. During those two decades, it has raised more than $2 million for educational programs and school materials for Tustin students. The sponsoring organization, the Tustin Public School Foundation, was founded in 1989 by parents and local leaders in response to the state's reduced school funding. (Courtesy Tustin Public Schools Foundation.)

CHRISTMAS TRADITION. Tustin Boy Scout Troupe 235 has sponsored a Christmas tree lot for fund-raising since the late 1960s. The troop credits scout parent Elmer Deibert with spawning the idea that raises funds for the troop and gives the boys a worthwhile project to be involved in. Originally the lot was located at the Southeast corner of Irvine Boulevard and Prospect Avenue and later moved to Seventeenth Street at Yorba Street. For the last 30 years, the troop has hosted the sale at Seventeenth Street and Newport Avenue on property generously donated by the Prescott family. (Courtesy Barry Deibert.)

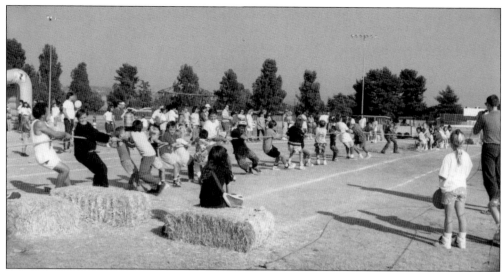

COMMUNITY ROPE. Adults and children engage in one big tug-of-war competition during the games at the annual Tustin Tiller Days celebration during the 1990s. Tiller Days activities were a bit simpler back then. The celebration of Tustin's agricultural roots began in 1957. Community groups manned most of the food and activity booths. (Courtesy Tustin Parks and Recreation Department.)

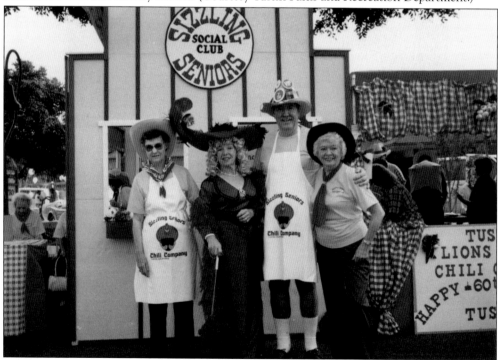

HOT STUFF. The Tustin Street Fair and Chili Cook-off celebrates its 27th anniversary in 2011. According to the International Chili Society, this is the largest one-day chili cook-off in the world. More than 1,500 gallons of chili are distributed in a five-hour period. It is a fun event for the whole family and raises tens of thousands of dollars for nonprofit organizations and schools. This photograph from the early 1990s shows the seriousness most participating teams put into their chili booth presentations. (Courtesy Tustin Parks and Recreation Department.)

Tustin's Museum. The Tustin Museum was created in 1975 by the Heritage Committee of the Tustin U.S. Bicentennial Foundation to celebrate local history during our nation's bicentennial. Committee members Carol Jordan, Mary Etzold, and Vivien Owen collected and documented historical artifacts and old photographs, working to establish a history museum for the city. They used the old post office on Third Street for their first displays. In 1976, the triumvirate organized a more formal Tustin Area Historical Society to continue the effort. A few years later, the museum moved to its current location, shown above, in the Knights of Pythias building at 395 El Camino Real. The museum has a large variety of exhibits from Tustin's past including the city's first fire truck, a converted 1912 Buick touring car, and a host of agricultural and "early technology" displays. The Tustin Area Historical Society hosts the annual Old Town Tustin Promenade, now in its 17th year, featuring a home and garden tour of many of Old Town Tustin's unique or picturesque locations. Proceeds from this event, as well as donations and memberships, allow the society to provide programs to stimulate historical interest in the area, protect historical papers and photographs for future research, and continue their "History-in-a-Box" program for over 100 third-grade classes in the Tustin Unified School District. If interested in visiting the museum, learning more about the society, or supporting their work, call them at 714 731-7691 or visit their website at www.TustinHistory.com. (Courtesy Guy Ball.)

www.arcadiapublishing.com

Discover books about the town where you grew up, the cities where your friends and families live, the town where your parents met, or even that retirement spot you've been dreaming about. Our Web site provides history lovers with exclusive deals, advanced notification about new titles, e-mail alerts of author events, and much more.

Find Your Place in History.